The **Paul**
Hornung
Scrapbook

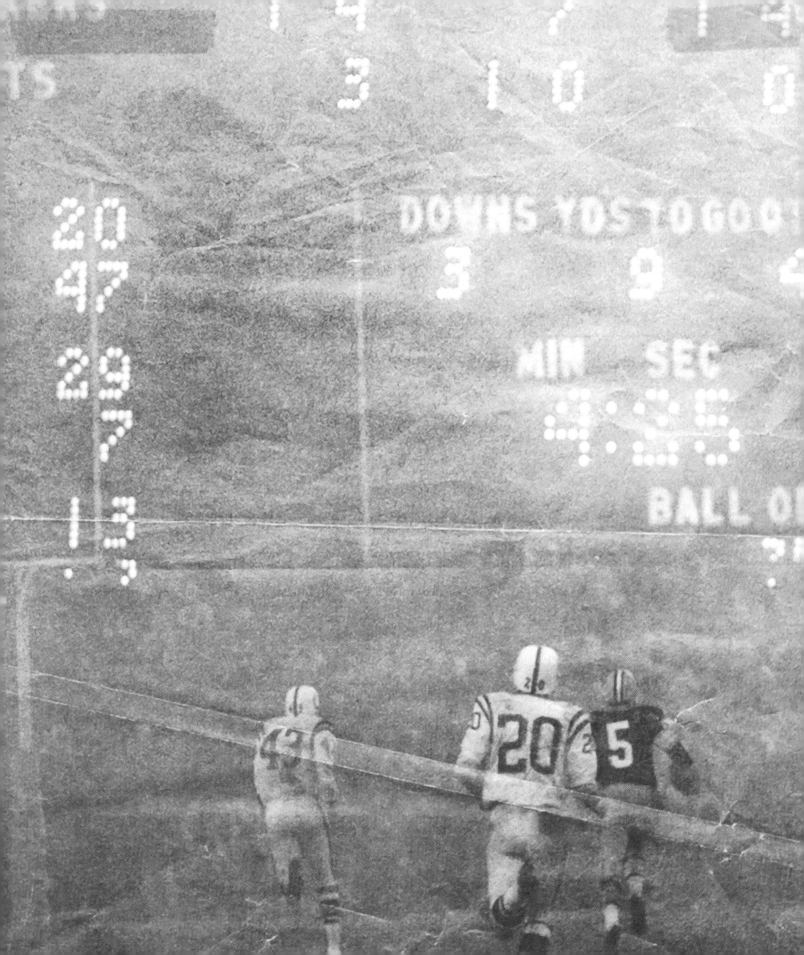

The Paul Hornung Scrapbook

Paul Hornung and
Chuck Carlson

TRIUMPH
BOOKS

This book is available in quantity at special discounts for your group or organization. For further information, contact:
Triumph Books LLC
814 North Franklin Street
Chicago, Illinois 60610
(312) 337-0747
www.triumphbooks.com

Printed in U.S.A.
ISBN: 978-1-60078-993-9
Design by Andy Hansen

Photos courtesy of the author except where otherwise noted

CONTENTS

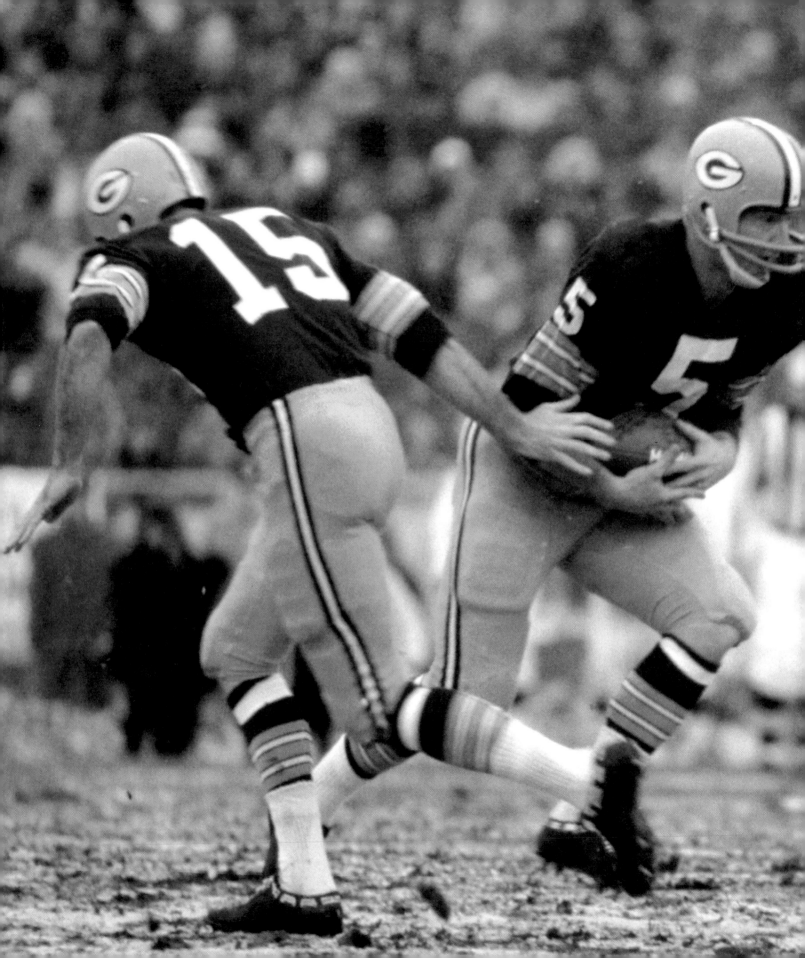

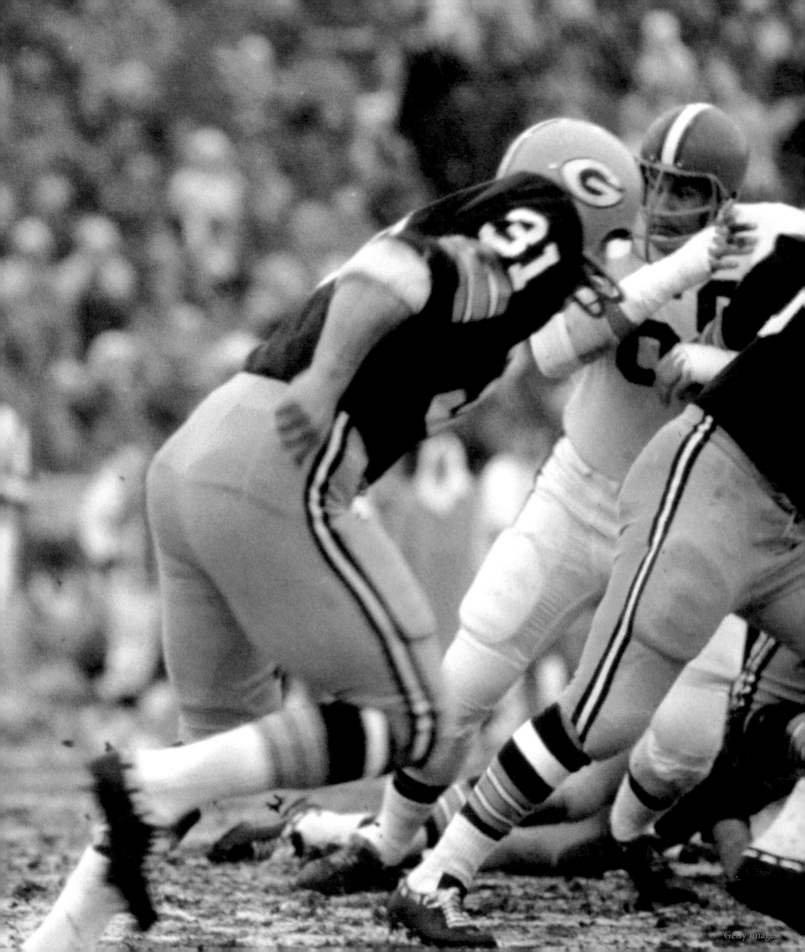

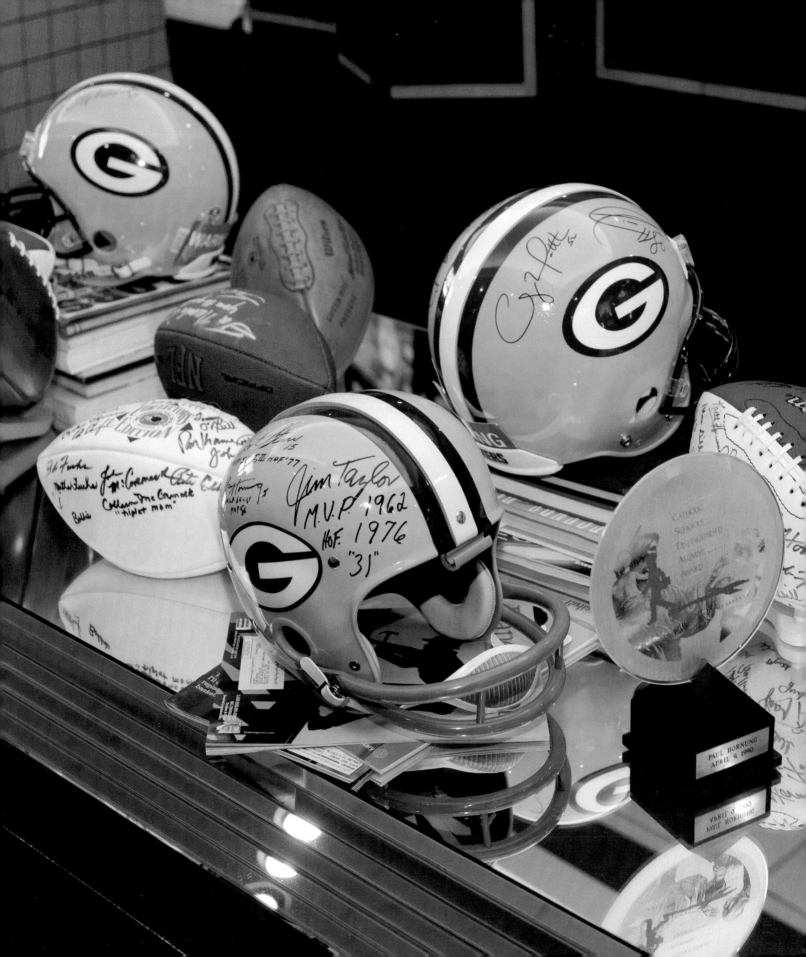

INTRODUCTION

He has worked in the same office in the Watermark Tower in downtown Louisville, Kentucky, for more than 30 years. Tucked on the 11th floor next to the Louisville Community Foundation, there is a non-descript door with the name "Paul Hornung" on it. Indeed, that's all it really needs to say.

Nearly everyone in the building knows him. To them, he's just "Paul" or "Mr. Hornung," who, more often than not, can be found with his aging French bulldog Louie, who has almost as much trouble walking these days as his owner does.

But even at age 78 and with bad knees and sore hips and a troublesome back that keep him from playing his beloved golf, Hornung still cuts a wide, impressive swath. There is still the twinkle in the eye and the quick wit that make him one of the great storytellers in pro sports.

Profane and outspoken and so honest it can get him in hot water on occasion, Hornung has never much cared what people thought of him. He has always been that way—from his days as one of the best high school athletes in the country to his days as one of the best college athletes in the country to his days as one of the best pro football players to his days as a successful businessman.

He knows everybody and makes sure everyone knows it too. In his office, he has the kind of sports memorabilia that is practically priceless. From signed boxing gloves by Muhammad Ali to an invitation to the White House from President Ronald Reagan to dozens of signed photos of him from his days with the Green Bay Packers, Hornung lives comfortably in his past, knowing full well what he did and can still do.

He has rubbed elbows with seemingly everyone—from Frank Sinatra to Marilyn Monroe—and if there's a nightclub he did not frequent in his younger days, then it's only because no one told him about it.

He recalls a young, talented, brash heavyweight fighter, also a native of Louisville, named Cassius Clay who would win a gold medal in the 1960 Olympics. In the years to follow, Clay would change his name to Muhammad Ali and he and Hornung would remain friends.

"Whenever he was in town he would call me and say, 'Come on Paul, let's go downtown and stop traffic.'"

Imagine that. Paul Hornung and Muhammad Ali prowling Louisville— what a sight, and what a night, that must have been.

"It's been fun being me," he said with a smile. "I think I've done a pretty good job of keeping my name in the public. I do some charitable things around Louisville when I can. I have my charities I'm involved in which I think are very significant."

Hornung's desk, also piled with memorabilia from his days in the NFL, butts up against a spacious picture window that offers a dramatic view of the city that has meant so much to him his entire life.

And while he's all but retired from the real estate and soy bean business that made him and his now late partner Frank Metts wealthy, he is never sitting still because he has another career that means just as much, if not more, to him: being a once and future member of a Green Bay Packers dynasty that will never be forgotten.

These days, his calendar is full with events and speaking engagements and dedications and autograph signings and public relations obligations. And most of them relate to his days playing for the Packers. He remains firmly

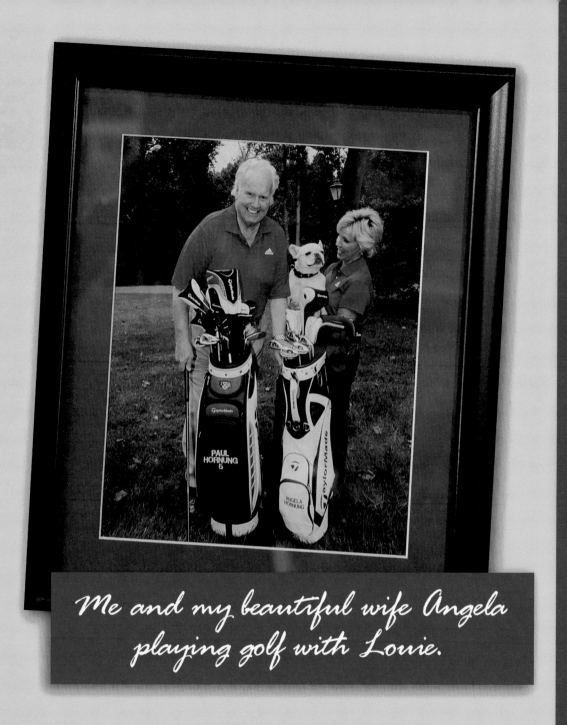

Me and my beautiful wife Angela playing golf with Louie.

entrenched in the community that has meant so much to him and which has done so much for him.

In 2010, he created the Paul Hornung Award, in cooperation with the Louisville Sports Commission, which has developed into one of college football's major awards. It is presented in a grand yearly banquet to the player designated as the most versatile in major college football.

And maybe that's the way it should be since Hornung was indeed the most versatile player both in college and the NFL. At Notre Dame, he was a running back, quarterback, kicker, and defensive back and earned the Heisman Trophy as a senior. In Green Bay, he played halfback, fullback and kicked. He was, according to his legendary coach, Vince Lombardi, the most versatile player in the league. And nobody was better inside the 5-yard-line than Hornung.

"He could smell the goal line," Lombardi said.

He still travels to Green Bay to watch his team play. He still travels to many road games as well, and never, ever misses a chance to go to Chicago, still one of his favorite cities in the world, for the opportunity to watch his Packers play the Bears.

He was part of a Packers team that continues to occupy a place in myth and lore. It was a team full of Hall of Famers and rakish characters. It was a team that football fans of today can still identify with, even though they played long before most of them were born.

Playing in the NFL's smallest city, the Packers of the early to late 1960s were the gold standard and, even now, they are viewed with a kind of reverence that those players understand all too well.

They were coached by a mercurial genius, Vince Lombardi, who demanded more from them than even they thought they were capable of providing. And in a span from 1960 to 1967, the Packers won five NFL titles, including the first two Super Bowls ever played.

Paul Hornung, though he never played in a Super Bowl (he was injured in the first one and had retired the next year), still wears a massive Super Bowl ring and revels in those days, remembering his friends, living and dead, as well as opponents, many of whom stand side by side with him in the Pro Football Hall of Fame.

He is still "The Golden Boy," a nickname hung on him by a Louisville sportswriter, Tommy Fitzgerald, when he was becoming a college phenom and it's a nickname he never tried to run away from.

Hornung looks out the window of his spacious office and points south, to the area known as Portland, a ragged and rugged part of town where he grew up with Loretta, the mother he adored.

"Great athletes over there," he said. "Always were and always will be."

And Paul Hornung was one of them.

The games he played always seemed to come effortlessly to him. A three-sport star at Flaget High School in Louisville, he was a good enough basketball player to attract interest from University of Kentucky coach Adolph Rupp. He was such a good baseball player that the Cincinnati Reds showed interest.

But it was football where Hornung believed his future would reside. He wanted to go to Kentucky and play for Paul "Bear" Bryant, but his mother always had designs on him going to Notre Dame and he wasn't about to disappoint her. After all, after his father, Paul Sr., walked out on the family when he was baby, it had been just the two of them. She had provided for him, she had sacrificed for him, and he was going to make her proud.

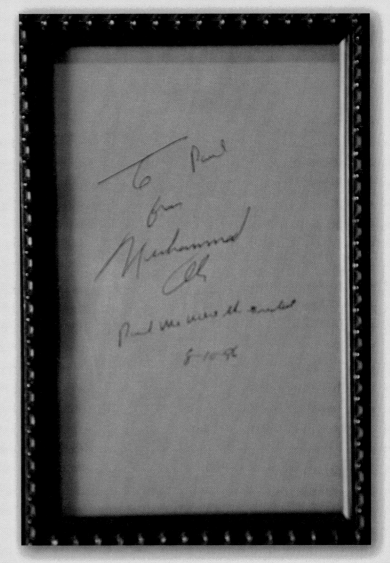

An autograph from the Champ:

To Paul — from Muhammad Ali —

Paul we were the greatest — 8-10-86

Four years later, he was the first—and still the only—college player to win the Heisman Trophy on a losing team. He was a quarterback and a halfback and a defensive back and a kicker who could run and catch and throw. He was everywhere, doing everything, and he played with a joyful intensity that left everyone amazed. He was possessed of a confidence that bordered on the arrogant and he made no apologies for it then and he makes no apologies for it now.

Paul Hornung has been the subject of two books over the years. The first, published in 1965, was written with Louisville sports writer Al Silverman and was titled, not surprisingly, *Football and the Single Man*. It was written as Hornung's days in the NFL were coming to an end. He had enjoyed a wonderful, turbulent career that not only included world championships and an MVP award but the ignominious suspension from Commissioner Pete Rozelle for gambling on football games.

The second book, *Golden Boy*, was published in 2004 and was a view of the lion in winter, looking back on a career that was everything he could have hoped but which, just maybe, could have been a little better.

There was actually a third book he was involved with called *Lombardi and Me*, written in 2006, in which he helped chronicle the remembrances of former players, coaches, and writers and their unforgettable dealings with the legendary coach Vince Lombardi.

And this book, *Paul Hornung's Scrapbook*, comes nearly 50 years after his last game and focuses on many of the items that have meant so much to him over the years.

There are photos and letters and memorabilia, some which barely register with him until he looks at them and then, of course, the memories flood back with stunning, often hilarious, detail.

But others resonate within decades after the fact and they remain a valuable part of his existence, whether its photos of ancestors from Germany or of his beloved wife, Angela, or any of a hundred photos from the football field where he was always at his best.

Of course, some stories, still, remain locked away, never to be granted the light of day. Because, even for as public a man as Paul Hornung has always been, some stories, and the memories that go with them, belong only to him. And maybe that's the way it should be.

In most ways, though, he remains an open book, happily revealing himself to anyone who cares to ask and that's perhaps why his exploits will never be forgotten.

Few people remember that his career really ended, technically, with the New Orleans Saints, who selected him in the expansion draft in 1967. But he never played a game due to a neck injury and he retired, slipping seamlessly and comfortably into the next phase of his life, which included television commentary, his business interests, and being the best former Packer he could possibly be.

In his own words, Paul Hornung talks about his turbulent, entertaining life, viewed from the prism of experience and time. He doesn't talk about regrets because, to him, you can't talk about something you never had. He remains an original, a sporting figure from an American sports era that will never be seen again.

Like the picture window in his office that that looks out on the city he still loves, Paul Hornung can still see everything.

And he loves what he sees.

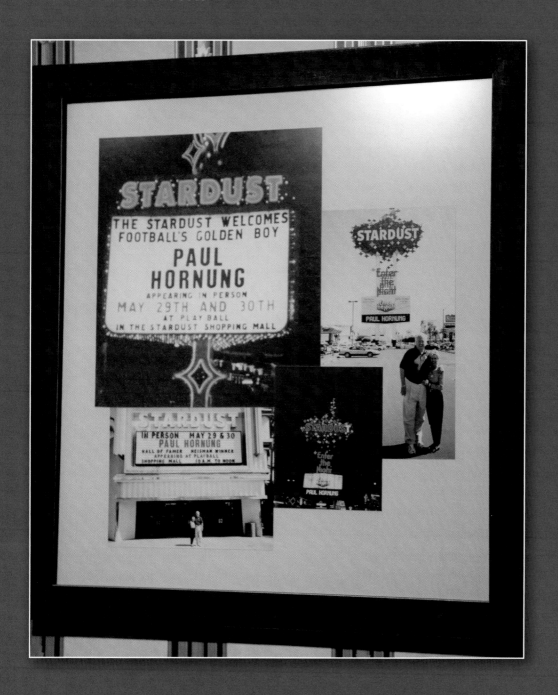

Me at six or seven years old.

A Home in Louisville

The early Hornung family after arriving from Germany.

Louisville has always been my home. As much as I loved the excitement and the bright lights of cities like Los Angeles, New York, Miami, and, my favorite city of all, Chicago, Louisville has always been home and always will be.

The people here have always been good to me and they have been behind me from the beginning. Even when I was suspended, they were behind me and it has always been important to me that I represent the town. This place has always been important to me. It's important that they're proud of me and I think they are. I've tried to live the kind of life in which they will be.

The sports columnist Jim Murray once called my hometown "America's bar rag," and while a lot of residents took offense to that, I didn't. The Louisville I knew growing up was a city of whiskey distilleries, cigarette factories, and gambling at Churchill Downs, home of one of my favorite events in the world, the Kentucky Derby.

My mom, Loretta Hornung.

I was told that as a baby I loved to play with balls in my crib, so maybe that was the start of my love for athletics. And sports proved to be a terrific outlet for me because, growing up, life wasn't the easiest. My folks divorced when I was two or three, and my dad, who was never an athlete, left because of his alcoholism. He lost his job with the Metropolitan Life Insurance Co., first in New York and then in Louisville, and left us. He took the car and she kept the furniture and me. I never knew my dad growing up. I was always raised by my mom.

She was born and raised in Louisville and in 1939 she got a job with the Works Progress Administration as a clerk-typist and we lived in a two-room apartment above my grandfather's grocery. She worked her whole life in Louisville.

And though I grew up in the poor part of Louisville, called Portland, my mom and I had a good life, but I always knew I wanted to compete in sports. I was bigger than most of the other kids my age so I ended up playing on the eighth grade football team at St. Patrick's School even though I was only in the fifth grade.

By the time I was in eighth grade, I was the starting quarterback. It was funny, our coach, Father William O'Hare, let me call all the plays because he knew nothing about football.

I also developed an interest in kicking because no one else on the team had much interest in it. I basically taught

Me and Mom.

myself, kicking ball after ball at the playground near our house at the Marine Hospital in Portland. And once I started doing it, I liked it. Later, when I went to Flaget High School, I'd practice kicking the ball over the basketball hoops on a playground on Bank Street.

It's funny, I'd use my imagination while practicing my kicks, pretending there were just a few seconds left in the game and I had to make the field goal to win the game.

It was also around this time that someone entered my life who would have a profound impact on me. Bill Shade, one of the great athletes in Louisville history, gave me my start. He was a great city player.

The Louisville Colonels, the Class AAA affiliate of the Boston Red Sox, signed him to a contract and he seemed to be on his way, but then his wife got pregnant and they ended up having triplets. He was 23 or 24 at the time and just couldn't afford to be on the road playing baseball, so he gave it up. It was sad because he might have made it to the major leagues. He ended up getting a job with the union in Louisville and he always looked out for me.

He saw that I had some abilities athletically and that's what drew him to me. Once he gave up his baseball career, he began playing fast-pitch softball and he taught me a lot about how to play. He also kept me supplied in baseballs and gloves. He was a special guy.

I ended up being all-state in football and basketball but I also loved baseball. I had a shot to maybe get a tryout with the Cincinnati Reds but nobody ever let me pitch in baseball. This is a true story: the only game I ever pitched, I pitched a no-hitter and lost 10-9 because I hit 20 batters.

But both football and basketball were my favorite sports. I played four years of basketball and four of football in high school and I thought I could play both in college. But when colleges like Alabama and LSU want you for football, you kind of know that's your best sport.

And I remember Kentucky came after me really hard to play football. Bear Bryant was the coach there at the time and he really wanted me. And I really wanted to go to Kentucky.

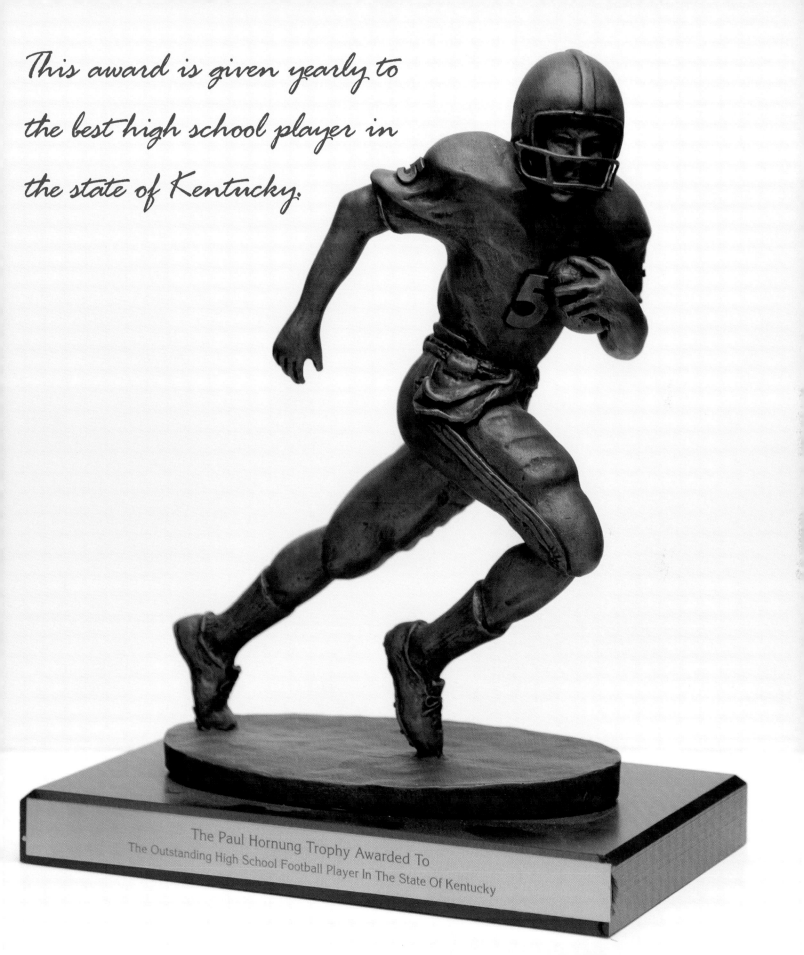

This award is given yearly to the best high school player in the state of Kentucky.

The Paul Hornung Trophy Awarded To
The Outstanding High School Football Player In The State Of Kentucky

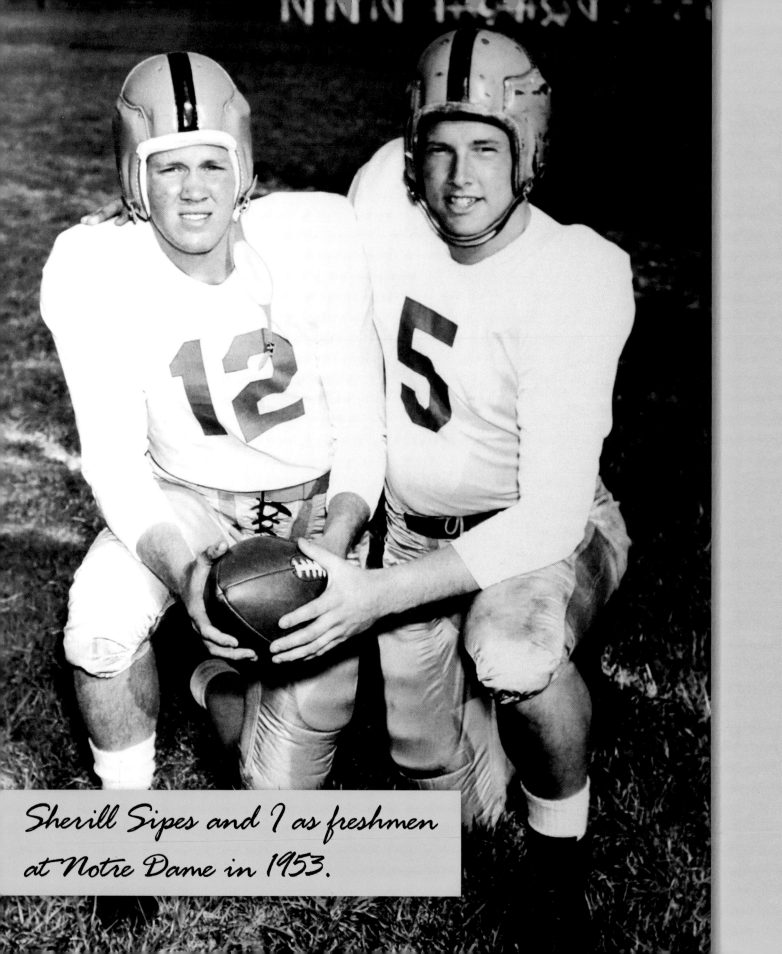

Sherill Sipes and I as freshmen at Notre Dame in 1953.

Bear Bryant, being the sharpie he was, he went to Kentucky's basketball coach, Adolph Rupp, and asked if I could play for the team. And he gave it the okay. I didn't even know if I could make the team but, for heaven's sake, when you're a youngster you want to play two sports if you can.

But my mother really wanted me to go to Notre Dame. I was an Irish-Catholic kid and it had always been her dream for me to attend Notre Dame, even though I wanted to go to Kentucky and play football for Bear Bryant and basketball for Adolph Rupp. But she's the one who wanted me to go to Notre Dame so her choice was my choice. If I hadn't gone to Notre Dame, I think it would have broken her heart.

Of course, it ended up being a great decision because playing football at Notre Dame opened a lot of doors for me.

It also helped that my best friend, Sherrill Sipes, was considering going to Notre Dame as well. Sherrill was every bit the athlete I was. We met in eighth grade when his Christ the King team played my St. Patrick's team in football. He was from what I considered the "good" side of town, while I was from the tougher Portland section and I didn't like him at first because he complained about how rough we played.

But we both ended up going to Flaget High School and became friends—in fact, we were almost inseparable. We did just about everything together. I remember we used to be ushers every year at Churchill Downs around the Derby and after taking tickets for a while, we'd eventually let people in for 50 cents. We'd bet on some races, steal mint juleps from people who weren't paying attention, and generally have a great time. Sherrill was always a little more cautious than me but we were great friends.

In the early spring of our senior year in high school, a Notre Dame recruiter drove Sherrill and me to South Bend to meet with Notre Dame's coach Frank Leahy. Neither of us were impressed with what we saw, especially since it was still cold and the students were away on break. We had both made the decision to leave and not bother with it. Then we met Leahy.

I'll never forget this, he said, "Lads, Our Lady needs you here. Lads like you belong in a Catholic college. You belong to Notre Dame. You should matriculate at the finest university in the world. If you're going to play professional football, there's a back door and there's a front door. This is the front door."

And I remember he looked at me and said, "Not only will you get a good college education here, but I think I can make you the greatest football player in the country."

That's all we needed to hear. I had been planning to go to Kentucky but that speech, and my mom, changed my mind. I told mom she could stop praying on her rosary beads every night. Sherrill and me signed the same night with Notre Dame.

But I still had to tell Bear Bryant that I was not going to go to Kentucky and Bryant is not a man who takes no for an answer very easily. But then a year later Bryant left Kentucky to take the head coaching job at Texas A&M. I had heard he left Kentucky because he was mad that university officials did not fire Adolph Rupp after a highly publicized point-shaving scandal involving the basketball team. I'm not sure if that was true.

I actually got to know Coach Bryant very well over the years and whenever he'd return to Kentucky for speaking engagements, he'd tell audiences that he left Kentucky because he wasn't able to sign me. I know it was a joke but there was a part of me that wondered if there was a little bit of truth to that.

Bart Starr and I—side by side at our induction into the National High School Hall of Fame.

Under the Golden Dome

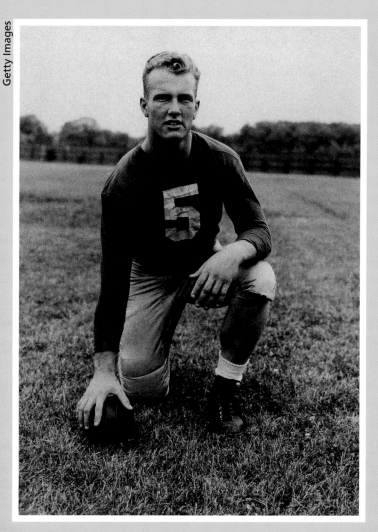

At Notre Dame

I'll admit it, it took me awhile to understand just what the mystique was that surrounded Notre Dame. And it took me just as long to figure out if I even wanted to be a part of it.

I had been recruited by a lot colleges coming out of high school. As I said, I wanted to go to Kentucky, but all the schools in the SEC really came after me—Tennessee and Coach Bob Neyland came after me really hard.

But in the end, my mother and Coach Frank Leahy really swayed me. The success that he had brought to that school was hard to ignore. Yeah, it was located in Indiana, which I had never been to and which I heard could be cold as hell, but in 11 seasons he compiled an 87–11–9 record and won five national titles. For a lot of people, Notre Dame *was* college football, and I wanted to be part of that. At least I thought I did.

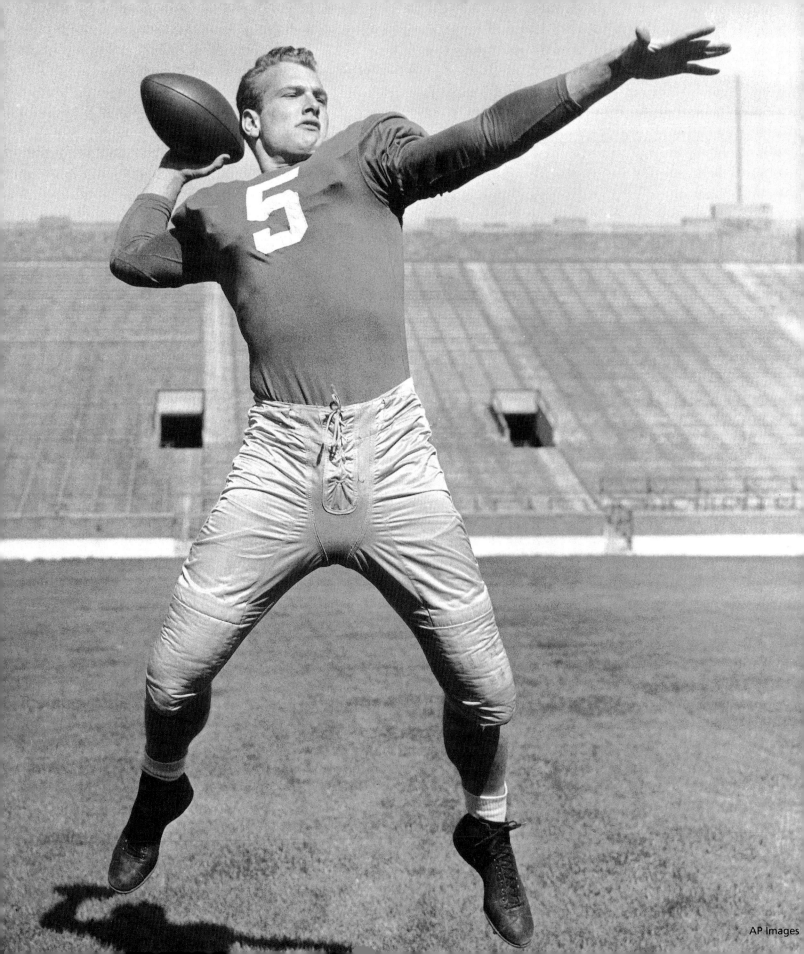

I came to Notre as a freshman in the fall of 1953 with my great friend Sherrill Sipes. We had signed our scholarships the same night and went to college together, knowing that whatever we faced, we'd face together. And if Sherrill hadn't been there, I don't know if I would have made it.

It really did take us a while to warm up to Notre Dame and everything that went with it. There might have still been a part of me that wished I'd gone to Kentucky, in fact I'm sure there was. I was homesick and cold. Hell, I didn't even have a warm coat.

On top of that was the fact that I wouldn't even be able to play that first year since it was still the era when freshmen weren't allowed to play on the varsity.

During that time, Sherrill and I did something pretty spur of the moment, and looking back, it was pretty damned stupid. I think it was about two months into our freshmen year and we decided we'd had enough. This place wasn't for us—or so we thought then. So we wrote letters to the University of Miami in warm, sunny Florida saying that we wanted to transfer. Miami? I wasn't sure what they even had in the way of football program but I really didn't care. It would be warmer, there would be plenty of girls and I'd still get the chance to play football.

Of course, looking back now that was a pretty damned stupid thing for us to do. But we were kids and, of course, we never mailed the letters. I sometimes wonder what would have happened if we had.

The saving grace was football practice, where I was often brought up by Leahy to scrimmage against the varsity. It was in practice where I could show what I could do and that helped a lot and I began to figure out that I could play at this level.

My first real chance to play came in the 1954 Old-Timers Game, an annual rite that was the culmination of spring practice and pitted the freshmen against the graduating seniors and players from the past.

I think I did pretty well.

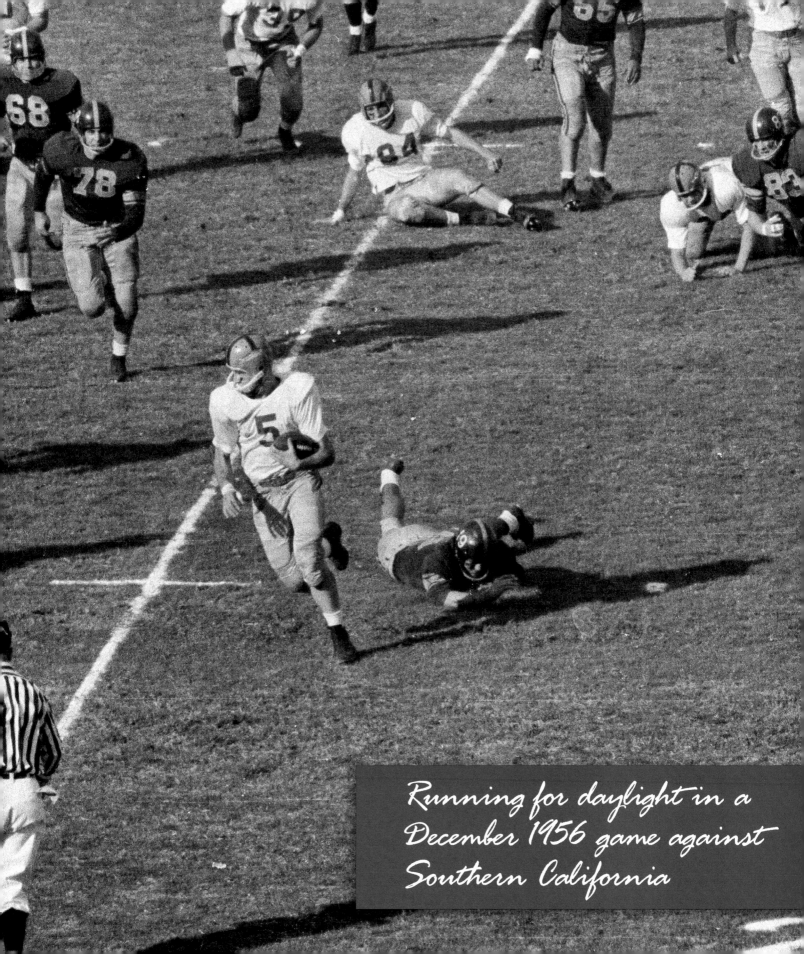

Running for daylight in a December 1956 game against Southern California

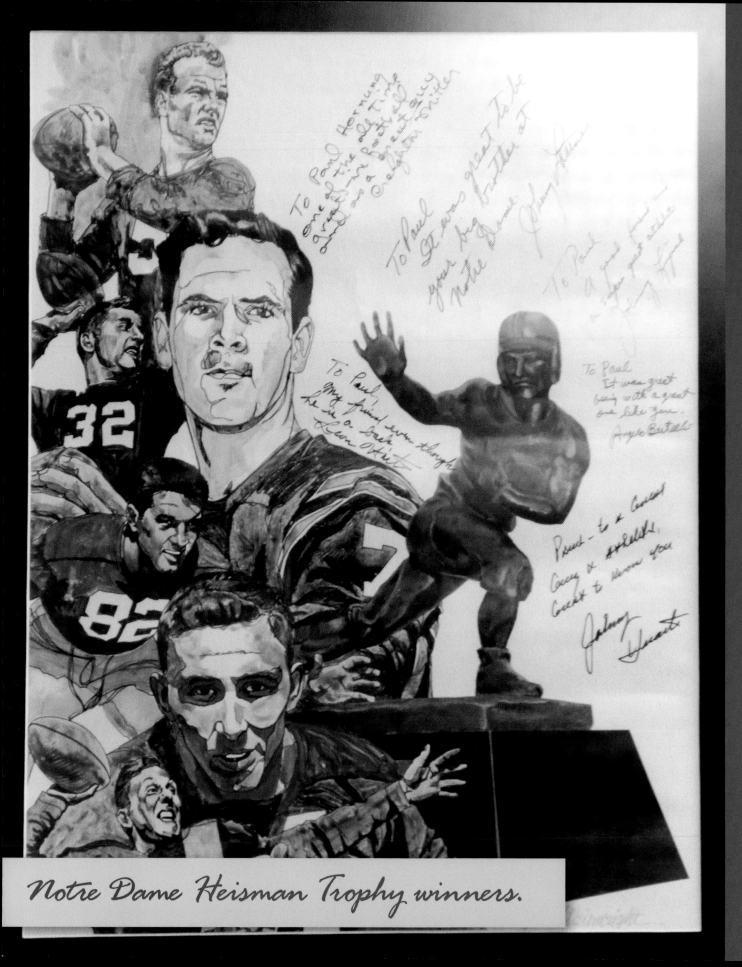

Notre Dame Heisman Trophy winners.

In one quarter as quarterback, I threw three touchdown passes, and Tommy Fitzgerald, a *Louisville Courier-Journal* reporter who was in town to cover me and the game, first called me "The Golden Boy." That name has stayed with me ever since. I guess I owe Tommy for that.

It had taken a little while but, finally, I got the whole aura that was Notre Dame football. I knew I could play at this level and was excited about finally getting a chance to work with head coach Frank Leahy on a daily basis.

But that off-season, a bombshell dropped: Frank Leahy was resigning as head coach for "health reasons."

I was pretty shocked and angry because he was one of the main reasons I had come to Notre Dame in the first place. I also didn't believe that health was the reason he was quitting. I knew he did have health issues because he'd collapsed in the locker room during a game in 1953 due to an attack of pancreatitis. They said the attack was so serious that a priest was called in to give Leahy the Last Rites, but no one really knew for sure.

And while I'm sure that was an issue, I think Leahy was shoved out the door by the Notre Dame administration because the school, which was really conservative, believed he had become bigger than the program. And, in their view, no one was bigger than the school. That was a stupid reason if it was the reason. Still, it was shock and I think the Notre Dame people probably regretted that decision.

But I was just a player and I played for whoever the coach was and, in this case, it ended up being Terry Brennan, who'd been the coach of the freshman team. I liked Terry Brennan. He was no Frank Leahy, but nobody was. But if someone had to come in and take over, I'm glad it was Terry. Looking back, he never got the credit he deserved. He took over an almost impossible situation.

In those days you played on both offense and defense, so I learned to play defensive back. I had good size (6'3", 195 pounds) and I could run so I wasn't too concerned about it.

I was also listed on the depth chart as the No. 4 quarterback and the No. 2 fullback. And I was the kicker and, for some reason, I was kicking the ball a lot farther in college than I did in high school. I don't know why that was.

Also, my uniform number had always been 20 all through high school, but when I got to Notre Dame all the quarterbacks had to have numbers in the single digits, so I took No. 5 in honor of my idol Joe DiMaggio of the New York Yankees. I always loved the way he played. When I told him that few years later, he really liked that.

Ralph Guglielmi was the quarterback that year and he was a hell of a player. He really helped me a lot. As the season went on, I played some fullback and defensive back but it was pretty clear Terry was grooming me to take over for Ralph at quarterback the next season.

Ralph was just a great player. He was a first team All-American and he could do just about anything. He gave me a great piece of advice at that time. He said, "Paul, whatever you do, get on the Dean's List your senior year, then you can just show up for class and it won't be a problem." So I majored in business and really worked at it and I made the Dean's List. Ralph was right.

We ended that season 9–1 (our only loss was to Purdue) and I was pretty happy with how my season went.

Most of the time from January on I watched the basketball team and I got more interested in playing basketball. I always thought I could have made the basketball team and I actually played for Coach Johnny Jordan my sophomore year.

He'd lost a lot of players from the previous season and he knew I could play a little bit so he invited me to come out. I ended up being the sixth or seventh man and I averaged about six points a game. It was fun. But Terry Brennan didn't want me to play basketball. He wanted me to concentrate on football and my studies. So I refused to go out for the basketball team as junior, but I did play as a senior.

One of my biggest thrills as a basketball player, I got a call from Abe Saperstein, the coach and owner of the Harlem Globetrotters, to play against the Globetrotters. So I played against them in Chicago and in Michigan City, Indiana. God was that fun.

That's right when the Globetrotters were really becoming famous and that's when I played. I remember in the game in Michigan City I made my first four shots of the game and the Globetrotters great center, Meadowlark Lemon, said to that great guard of theirs, Marques Haynes, "Goddamnit, get on that boy." I never made another one against them.

They gave me $1,000 to play against the Globetrotters and I'd never seen that much money before. That was the highlight of my senior year.

That off-season, Ralph also introduced me to some interesting characters, including Julius Tucker, a Chicago trucking executive, and he introduced me to Abe Samuels and a nightclub owner named Manny Sear and between them they showed me some of the nightclubs in Chicago. I ended up spending a lot of time in Chicago. And through Abe Samuels, I also met some celebrities like Tony Bennett, Sammy Davis Jr. and Dean Martin. That's when my name started appearing in newspaper gossip columns. And that was okay with me. I never lacked for confidence anyway.

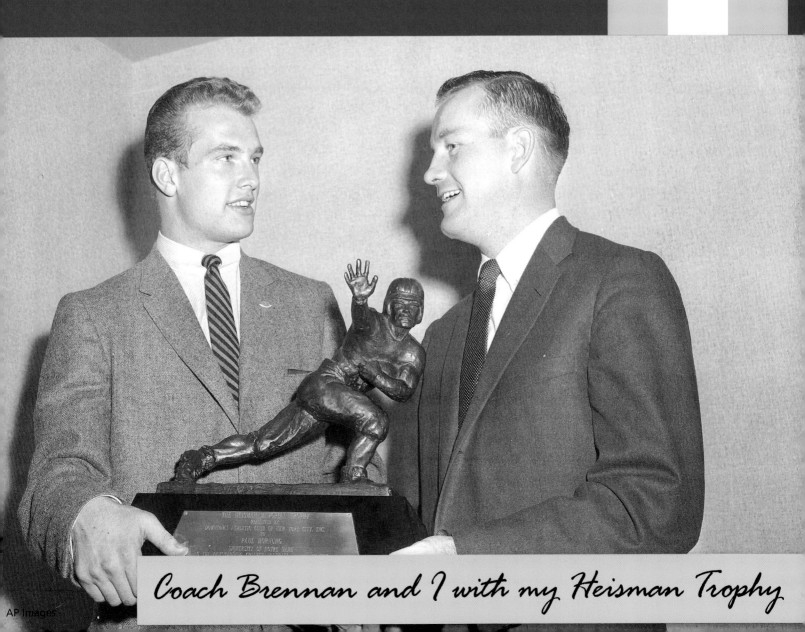

Coach Brennan and I with my Heisman Trophy

But football was still what I was concentrating on, and I knew going into my junior year at Notre Dame that we could be pretty special. I had a hell of a 1955 season.

I remember a game against Navy that we won 21–7 and I scored one touchdown and set up two others with an interception return and a nice run. I remember we trailed Iowa in another game 14–7 in the fourth quarter and I hit Jim Morse with a touchdown pass and then we got the ball back and I hit Morse with another pass. I kicked the field goal that won the game and, I'll never forget this, I was carried off the field by the fans.

THE EDWARD FREDERICK SORIN SOCIETY

THE UNIVERSITY OF NOTRE DAME GRATEFULLY RECOGNIZES

Paul V. Hornung

As A Member Of The Sorin Society

The next day Terry Brennan called me into his office and said he'd never known a player to be carried off the field in Notre Dame Stadium. Then he said, "Don't expect that to happen again. We don't do that at Notre Dame."

But I think my best game was the next week out in California against Southern California. I had a great game against USC. Out there I got a tremendous amount of publicity. I had a real good game. I played 59 minutes, threw for 354 yards, and had at least another 10 yards in return yards. We lost but that was probably the game that meant the most to me. It might have made me an All-American.

I was named All-American that year and the actress Kim Novak was our host for the All-American luncheon and dinners. God, she was so gorgeous. All the guys were looking at each other and wondering which of us should ask her out and I said, "Hell, I'll do it." She had just made the movie *Picnic* and she had been Miss Chicago. So I invited her to dinner. She said she'd love to go but she said she'd have to invite her agent, his wife, and a couple of other couples. I was going to go to the Stork Club and the owner had given me carte blanche. I could have taken her, but I couldn't take five other people. I told her I didn't have the kind of money to take five other people to dinner. And she said, "Well, I can't go without my agent." And I knew I was going to miss a hell of an opportunity. You always wonder what might have happened. I never lacked for confidence. I always got along with people.

We went 8–2 that season and I finished fifth in the Heisman Trophy voting behind Ohio State's Howard "Hopalong" Cassady, TCU's Jim Swink, Navy's George Welsh, and Earl Morrall of Michigan State. They were all seniors so that made me the front-runner for the Heisman in 1956.

Another great highlight for me that junior year was when Terry asked Jim Morse and I to do him a favor. There was a senator from Massachusetts who was going to be in town for an awards ceremony so he asked if the two of us would show him around the campus. We didn't really want to do it but we said okay.

That's when I met John F. Kennedy.

He walked with us to see the stadium and he was really impressed with what he saw. He said he was a big Notre Dame fan. Then we took him to the cafeteria and that's when Morse said something I'll never forget. He said to Kennedy, "Senator, I think you're going to be president of the United States one day," and that was in 1955. I remember Kennedy was flabbergasted.

When the tour was ending, he invited us to their summer home in Hyannisport. He said, "We play football every weekend." I wish I'd had the testicles to take him up on the invitation. He was one of the most beautiful people I ever had the opportunity to meet.

We'd had some pretty good success on the field in my first three years at Notre Dame and you never think that's going to end. But you're also conscious of the talent on your football team. You're smart enough to take a look at your schedule and know it was going be a tough year. We were confident we'd be successful, which we weren't. Terry Brennan was the coach and he was getting a lot of negative publicity because he was following Frank Leahy, one of the great coaches of all time. Fans still hadn't accepted him even though he was a hell of a coach.

In his first two seasons after having replaced Leahy, Terry had a 17–3 record but we hadn't won a national championship, so, naturally, a lot of people figured there was something lacking in the coaching. That doesn't make any sense.

But I sensed that 1956 would be different. We had a tough schedule that included games against some of the best teams in the country, including Michigan State, Iowa, and Oklahoma. It would be very difficult, but we were still considered one of the top teams in country at the beginning of the season, mostly because of history.

Jim Morse, he was a hell of a receiver, and he and I were the only returning seniors that year. I remember before that season, the two of us had dinner somewhere and I joked with him, saying, "We just went 8–2 last season, what if we go 2–8 next season?" Neither of us thought that was even remotely possible.

It was that season actually, when I made my first appearance on the cover of *Sports Illustrated.* It was October 29, 1956 and the title said "Paul Hornung…He Leads the Irish Against Oklahoma." But it was really no contest. Oklahoma, which would win the national championship and was one of the best college teams I had ever seen, clobbered us 40–0.

That happened a lot that season. We lost to Michigan State 47–14, a loss made even worse by the fact that I dislocated my thumb. We lost to another really good team, Iowa, 48–8, and we lost to another ranked team, Pittsburgh. But we also lost to Navy 33–7. Our only wins that season were against Indiana and North Carolina and, frankly, we barely won those.

The big problem was our defense. We ranked 106th out of 111 teams that year in points allowed, giving up 29 points a game. It was incredible. I said one time that I led the country in kickoff return yardage because teams were kicking off to us all the time. I wasn't really kidding either. We also barely averaged 13 points a game on offense and I ended up scoring just about half of our points all season.

We finished 2–8; it was Notre Dame's first losing season since 1933. I knew we weren't as good as previous teams but I thought we were a hell of a lot better than 2–8.

Through it all, though, I had a really good season. I was second in the nation in total offense with 1,337 yards, and while I threw 13 interceptions and only three touchdown passes, I rushed for 420 yards and six touchdowns. I really wasn't sure if I'd had the kind of season that would be good enough to win the Heisman Trophy, but I guess Notre Dame's reputation had something to do with it and I beat Tennessee's Johnny Majors in a really close vote.

It didn't help my case that we had a losing record because that was the first time a player from a losing team had won the Heisman. When I won the Heisman Trophy it was a surprise to the whole country but I took it in stride. I was very happy. It's one of the great awards in college football and I realized what a great tradition it was. I guess I was a little surprised, especially considering the competition. Johnny Majors was a great running back and Tennessee was unbeaten until the Sugar Bowl. Tommy McDonald and Jerry Tubbs from unbeaten national champion Oklahoma were third and fourth

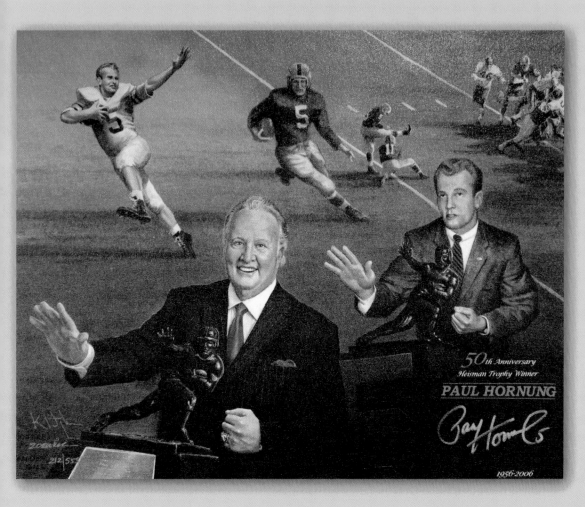

50th Anniversary
Heisman Trophy Winner
PAUL HORNUNG

1956-2006

on the list and number five was a pretty good running from Syracuse, Jim Brown. In the sixth spot was Ron Kramer, a tight end from Michigan and a future teammate of mine with the Packers. He is still one of the greatest athletes I have ever been around. Great hands, great speed.

Stanford quarterback John Brodie and Ohio State lineman Jim Parker, still the greatest lineman I've ever played against in the NFL, were next. So this was a real honor because there were a hell of a lot of great players on that list.

Still, I had some great games that year. Even though we were 2–8 I had some pretty good games. But it wasn't enough. One guy couldn't rectify the schedule as far as our talent was concerned.

I was named All-American again that year though on another All-American team I was demoted to second team because of our record

All of us went to New York again and that was a great story for me going back to New York and being introduced as part of the All-American team. We were introduced on the *Ed Sullivan Show* and that was a tremendous thrill.

It's funny, with the all criticism Terry Brennan took for his coaching, that was his only losing season as Notre Dame's head coach. He stayed two more years and his teams went 7–3 and 6–4, which still isn't too bad.

Even though I'd won the Heisman Trophy, I figured I still had plenty to prove as the NFL draft approached. I remember in the East-West All-Star Game, I was picked to be the East team's punter, thanks to the fact my coach at Notre Dame was picked as the head coach for that group. I still remember how Jerry Tubbs was selected as long snapper even though he'd never really done it before. During the first practice, Tubbs looked between his legs and saw me standing 15 yards behind him, the distance punters always stood.

Tubbs asked me, "Paul, do you have to stand so far back?" Told that was normal distance, he proceeded to misfire on several snaps. He then turned to me and said, "You have to understand, Paul, we never punted at Oklahoma." That was pretty funny.

Back then there was also the game between the college all-stars and the NFL champion from the previous season. They don't have that game anymore, and that's too bad.

We had some great players on that team. It was played in Chicago and we were coached by Curly Lambeau. Otto Graham was the offensive coach. Jim Brown, probably the best football player to ever play, was on that team and so was Jim Parker, still the best offensive lineman I've ever seen. But Graham didn't like me from the start and I didn't like him.

He started Len Dawson and then John Brodie at quarterback and he didn't start Jim Brown. Do you believe that? I knew how good Brown was. Everybody did. We started the second half and the first 10 plays of

the second half I handed off to him five, six, seven times and threw him passes in the flat. We scored a touchdown and we came off the field. Brown said, "That's it. I'm not going to play for that son of a bitch anymore." He was going to walk off and leave the field and go home and I told him not to do that. I told him not to give him the satisfaction. So he stayed but he never forgave Graham.

Not starting Brown was enough for me to see what kind of coach he'd be. Graham could have coached anywhere he wanted, but he didn't want the pressure. He would end up being the head coach of the Washington Redskins and he never had any success. I wasn't surprised. He took the easy way out, I think. I never forgave him for that, the way he treated me and Jim Brown in that all-star game.

My college career had come to what I thought was a pretty satisfying conclusion. We'd had a lot of success at Notre Dame as a team and even though we had a poor season my senior year, I won the Heisman Trophy. And I made my mom happy by getting my degree in business.

If I did have a regret—and I guess it's not really a regret—it's that Sherrill Sipes never got to play much and show what he could do. And that was just bad luck. We had gone to Notre Dame together, we were roommates, and we had been through so much together. But he dislocated his hip during his sophomore year and was never able to play again. God was that sad. Believe me when I say, he was every bit the athlete I was and if he'd stayed healthy he could have won the Heisman Trophy. That's how good he was.

He graduated from Notre Dame with a business degree and he became a very successful businessman. He still lives in California and is a lot like me, semi-retired but keeping his hand in his interests. You always wonder what might have been.

What it takes to be # 1

"Winning is not a sometime thing; it's an all the time thing. You don't win once in a while; you don't do things right once in a while; you do them right all the time. Winning is a habit. Unfortunately, so is losing.

There is no room for second place. There is only one place in my game, and that's first place. I have finished second twice in my time at Green Bay, and I don't ever want to finish second again. There is a second place bowl game, but it is a game for losers played by losers. It is and always has been an American zeal to be first in anything we do, and to win, and to win, and to win.

Every time a football player goes to ply his trade he's got to play from the ground up – from the soles of his feet right up to his head. Every inch of him has to play. Some guys play with their heads. That's O.K. You've got to be smart to be number one in any business. But more importantly, you've got to play with your heart, with every fiber of your body. If you're lucky enough to find a guy with a lot of head and a lot of heart, he's never going to come off the field second.

Running a football team is no different than running any other kind of organization – an army, a political party or a business. The principles are the same. The object is to win – to beat the other guy. Maybe that sounds hard or cruel. I don't think it is.

It is a reality of life that men are competitive and the most competitive games draw the most competitive men. That's why they are there – to compete. To know the rules and objectives when they get in the game. The object is to win fairly, squarely, by the rules – but to win.

And in truth, I've never known a man worth his salt who in the long run, deep down in his heart, didn't appreciate the grind, the discipline. There is something in good men that really yearns for discipline and the harsh reality of head to head combat.

I don't say these things because I believe in the 'brute' nature of man or that men must be brutalized to be combative. I believe in God, and I believe in human decency. But I firmly believe that any man's finest hour, the greatest fulfillment of all that he holds dear, is that moment when he has worked his heart out in a good cause and lies exhausted on the field of battle – victorious."

....Vince Lombardi

Thank You for Supporting the Arby Construction 2001 Make-a-Wish Event.

Paul Hornung – 2001 Celebrity Host

53

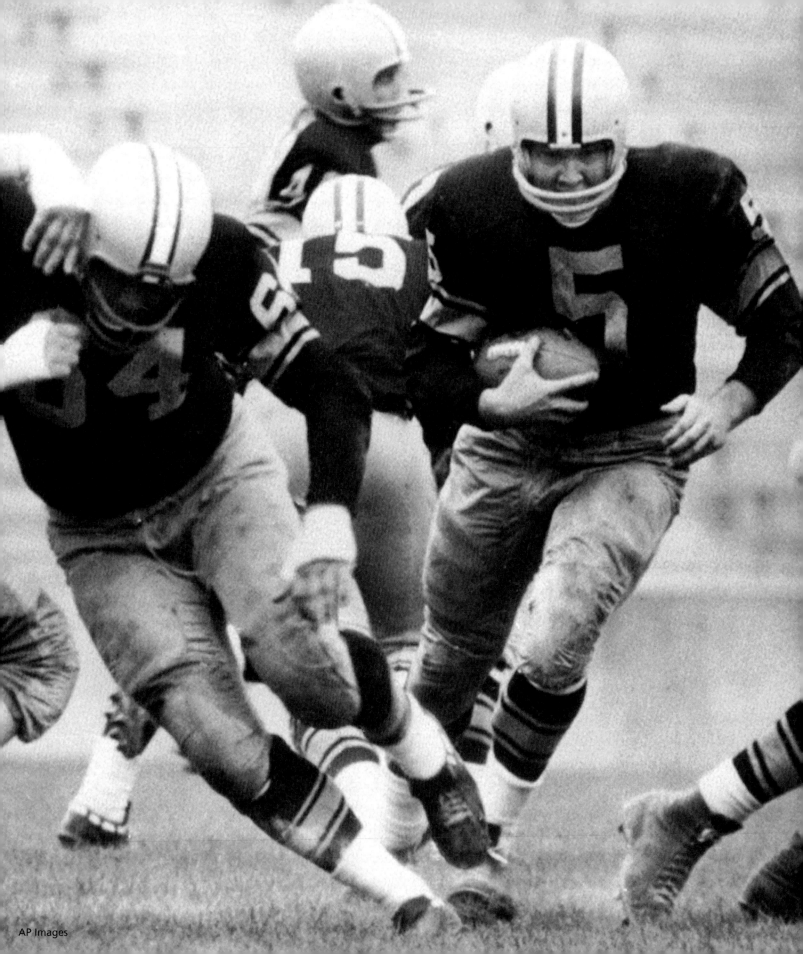

CHAPTER 3
Life in Green Bay

I knew I was going to be the No. 1 draft pick in the NFL draft that year and I knew I'd go to either the Chicago Cardinals or the Green Bay Packers. I knew a lot about Chicago and I knew almost nothing about Green Bay, other than it was probably a damned sight colder than it was in South Bend.

I did do a little reading, so I did know that the Packers had once been one of the most powerful teams in the National Football League. I knew the name Curly Lambeau and I knew he probably had the same reputation in Green Bay as Frank Leahy had at Notre Dame—great coach, maybe a bit of an ego. But they knew what they were doing. They were both great coaches who had probably outgrown their situations.

The Packers had won six NFL titles in a 28-year period from 1922 to 1949 under Lambeau but they hadn't done anything since. I also knew they had some of the NFL's first real superstars and that was interesting to me. There were players

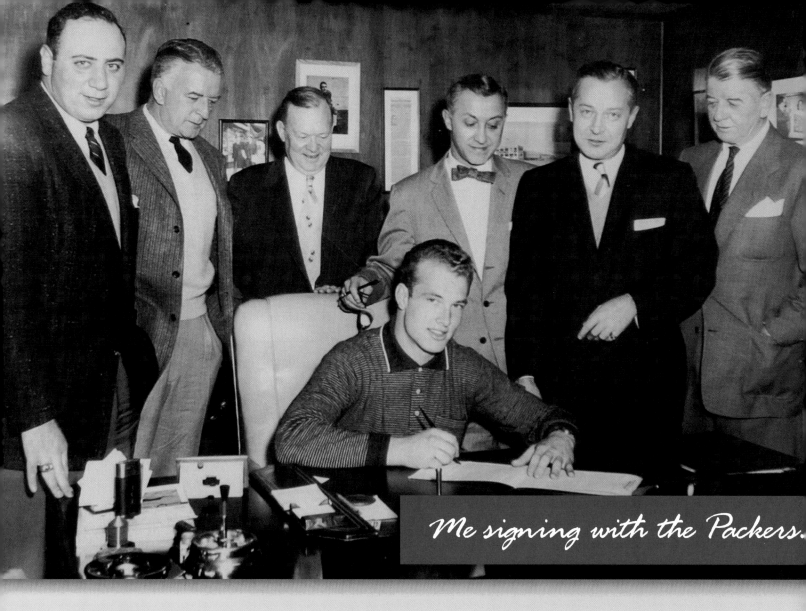

Me signing with the Packers.

like Tony Canadeo and Johnny McNally and wide receiver Don Hutson and they were all in the Hall of Fame. I thought there was no reason I couldn't be one of those players someday.

But the Packers that were going to draft me were pretty bad and they'd been bad for a while. If they hadn't been, they wouldn't be looking at drafting me. They hadn't won an NFL title since 1944 and they had really struggled in the 10 years since.

I knew Lambeau had clashed with the team's executive council but there was no owner to deal with because the Packers organization didn't have a single owner. I thought that was pretty damned strange but that's kept the Packers unique and kept them in Green Bay.

Lambeau left the Packers after the 1949 season and they really struggled after that. In fact, they couldn't even get to the .500 mark throughout the 1950s. It was kind of sad to see what had happened. I mean this was one of the original NFL franchises and it had a really proud and strong history, but now nobody who followed football really gave Green Bay a second thought. In fact, the franchise always seemed like it was on the verge of folding.

Part of me dreaded going there because I didn't want to get sucked into that mediocrity. But part of me was intrigued because I thought I could be part of a turnaround and, of course, I never lacked for confidence.

When I was at Notre Dame I became a Bears fan and, of course, Chicago was one of my favorite cities. I would have been fine with going to the Chicago Cardinals, too. After four years in a small town like South Bend I was ready for a place that was a little more stimulating in a lot of different ways.

But, deep down, I think I always knew I'd go the Packers. I don't know; I just did. And when they got the first pick, they called it the "bonus" pick back then, they wasted no time taking me and they immediately talked me up as the savior of the franchise. Part of me didn't mind that at all.

A lot of people don't know this but I did have the option of signing with Vancouver of the Canadian Football League, which offered me $50,000. And that was a hell of a lot of money for back then. But playing football in Canada? That just didn't seem right. I'd wanted to play in the NFL for as long as I could remember. That was where you proved yourself and I knew it. Of course, it also didn't hurt that my mom weighed in on the subject, as she did with most of the important decisions in my life. She wanted me to play in the NFL and I wanted to play in the NFL. So there was really no decision to make. I resigned myself to Green Bay. I was happy I was picked No. 1 because I figured it would get me a good salary.

It was a pretty quick negotiation, too, and I signed a three-year contract that would pay me $15,000 the first year, $17,500 the second year, and $19,500 the third year. I also got a signing bonus of $2,500, some of which I used to buy my mom a mink stole, some of which I used to buy a 1949 Ford convertible.

When I got to training camp, I really liked the guys a lot. My first roommates were Billy Howton, a terrific wide receiver, and Mac McGee. Max and I, of course, hit it off right away and we became lifelong friends.

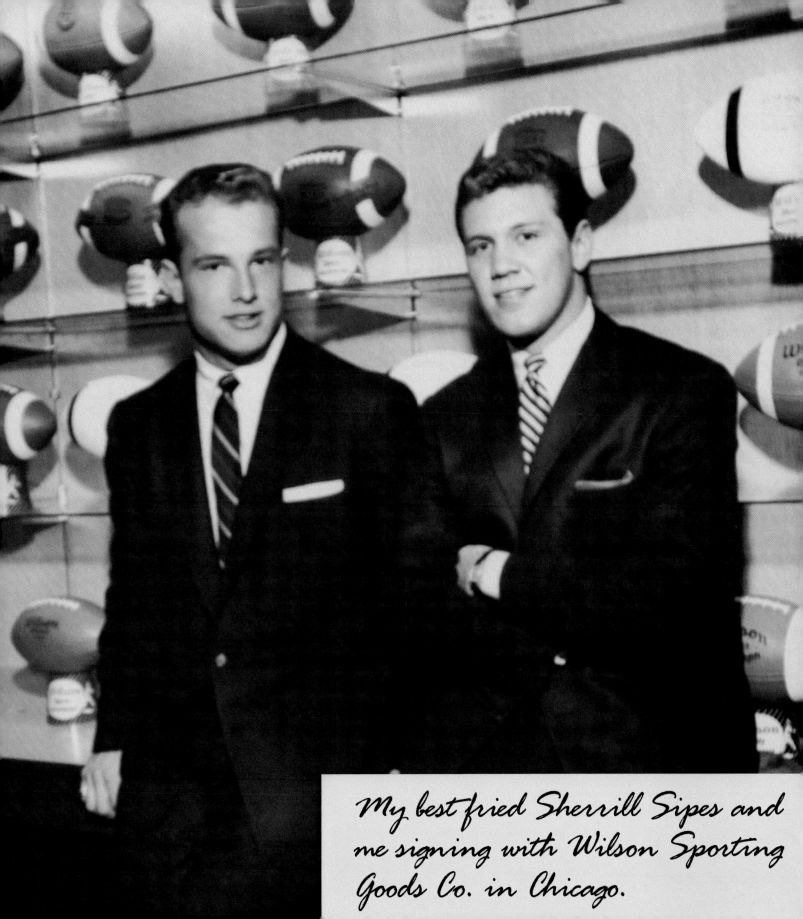

My best fried Sherrill Sipes and me signing with Wilson Sporting Goods Co. in Chicago.

But I could sense before long that trouble might be brewing because we had a coach who didn't know what the hell he was doing.

Lisle Blackbourn was in his fourth season as Green Bay's coach (he had compiled a 14–22 record in his first three seasons) and he wasn't sure what do with me. In fact, he had me practice at three different positions— quarterback, halfback, and fullback—and he didn't seem happy with me at any of them. I didn't know what the hell he was doing. I said, "I just want to play, put me anywhere and I'll perform." But he never did that. He never knew what to do with me and even today that puzzles me.

I think privately he thought I was a smart aleck who didn't take the game seriously enough and that I had a reputation built up from playing at Notre Dame. And maybe I did, but that never impacted how I played the game.

PAUL HORNUNG

GEORGE CONNOR AWARD & LIFETIME ACHIEVEMENT AWARD
UNIVERSITY OF NOTRE DAME & GREEN BAY PACKERS FOOTBALL
CHICAGOLAND SPORTS HALL OF FAME
2012

In truth, Lisle Blackbourn didn't like me. He didn't give me a real shot either. He tried me at quarterback and then at halfback and then back again. I never knew where the hell I was going to play. He'd move me back and forth. I don't think I got a fair shot at it. I thought I could play in the league but he didn't think I could.

I wanted to stay at one position. I wanted to play quarterback, but not under those circumstances. I don't think I would have prospered in that offense.

I did realize my rookie season that I couldn't throw the ball as well as I needed to be an NFL quarterback. But I knew if I needed to, I could play defense. I would have been a hell of a safety. I just wanted to play somewhere.

PAUL HORNUNG

That first season was no fun at all. I hated Green Bay and I hated the offense we were running. It was bland and conservative and it didn't suit me at all. I also hurt my ankle late in the season and really couldn't do anything to help the team. It was just a terrible season.

I ran for 319 yards and scored three touchdowns and I caught six passes. I completed 1-of-6 passes for –1 yard as a quarterback, I missed all four field goals I attempted, and we finished with a 3–9 record.

If there was anything positive from that season it's that the Packers board of directors had seen enough and they asked Blackbourn to resign after the season. He wouldn't do it so they fired him. The only problem was, he was replaced by Ray "Scooter" McLean.

With fellow Packers greats Bart Starr and Brett Favre and their wives.

Here I am with my wife, Angela, and Hall of Famer Willie Wood.

Ray was a really nice guy but he didn't know what he was doing. He was floundering. He was caught in the middle. He was trying to hold his head above water. He had a quarterback problem between Bart Starr and Babe Parilli. Nobody knew who was going to play and you can't go through a season like that. I had idolized Babe Parilli because he had played his college ball at Kentucky. I know it was a tough situation for him.

We ended up going 1–10–1, the worst season in Packers history. We weren't for shit. Scooter didn't know what he was doing. It was too much for him. He couldn't motivate anyone. No discipline at all. The veterans just overran him.

And I admit I did my share of that, too. Max McGee and I were roommates that season and Ray had an honor system policy for bed check. So Max and I took full advantage of it. We'd stay out until 4:00 AM some nights because no one was watching us. Looking back, we didn't help the situation, but I'm not sure we really thought about that then.

We had some terrific talent on that team. Jimmy Taylor was the rookie fullback and he actually took over my spot as the starting fullback the final two games of the season. On the offensive line we had Forrest Gregg, who's in the Hall of Fame, and Jerry Kramer, who should be in the Hall of Fame. We had Ray Nitschke at linebacker and Bart Starr at quarterback. They're in the Hall of Fame. I mean we had a hell of a lot of talent.

But we had no direction. I thought I could play better but I just needed to be in a better situation. That season had gone so badly I was seriously thinking of quitting football and I was only 23 years old. But it was no fun at that point.

But the rumors about me seemed to say otherwise. Green Bay isn't a very big town and the Packers, just as they are now, are the biggest thing in town. We had a terrible team but we still had the most devoted fans in football. They were great people who only wanted to see a winning team. But we did live in the fish bowl so everything that happened was made a lot bigger than it ever really was.

There were three bars a bunch of us liked to go to unwind. Back then you were really a part of the community, whether you wanted to be or not. I think a lot of people thought after a loss all the players went off and hid somewhere, crying about what had happened earlier that day. But that wasn't me.

I didn't like to lose but I wasn't going to let it ruin my day either. So after games and after practices, we'd go to one of three places in Green Bay—the Lyric Lounge, Speed's, or my favorite, the Piccadilly. In fact, that was my other nickname for a while, "Piccadilly Paul." And, damn, were there a lot of rumors.

One said Max McGee, a great teammate and my best friend on the Packers, and me were picked up on a road outside town at 5:00 in the morning after we wrecked a car. Damned if I know where that one came from. We were in our hotel room in Appleton (where we stayed the night before a home game), fast asleep. Really.

There was another that said Detroit Lions quarterback Bobby Layne—who enjoyed life even more than I did— and I were found drunk at 5:30 in the morning. It would have been an interesting story, except I didn't even know Bobby Layne at that point.

A third said that, while drunk, I did a strip tease at the Piccadilly while singing the song "Won't You Come Home, Bill Bailey." I remember I did take my coat and tie off and unbuttoned my shirt because it was so damn hot in there and, yes, I did sing. But there was no strip tease. In fact, I was the first one to leave with my date. That story really pissed me off at the time and that's where "Piccadilly Paul" came from, I think.

THE RUNNING BACK
by A. THOMAS SCHOMBERG

BEFORE THE GAME
by A. THOMAS SCHOMBERG

Statues at my home.

I also spent a lot of that off-season in Miami and Los Angeles. In Miami, I played a lot of golf with Eddie Arcaro, the famous jockey, and he knew I had a lot of interest in race horses. I also spent a lot of time in Hollywood. God, was that a great place. I met a lot of people. I hung out with the sons of Bing Crosby and we'd go see Sammy Davis Jr. and Dean Martin perform every night. And there were some great nightclubs. I had a great time.

I loved it in Hollywood, just loved it. A friend of mine in Hollywood could always find me a beautiful girl to date. I was always in a good spot and I could get into any private club there. People would always say, "There's Paul Hornung" and they'd buy me a drink or I'd get in a club. It was great.

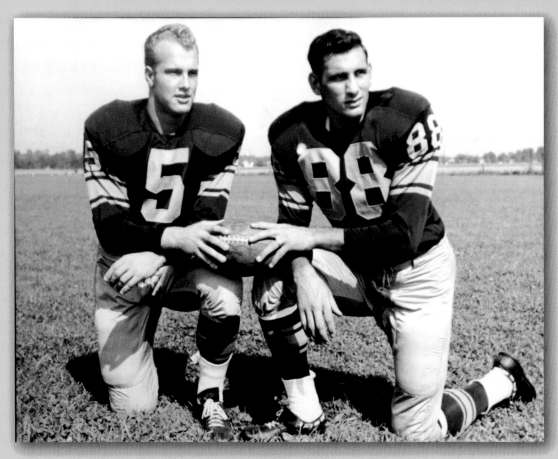

Me and Ron Kramer—the best athlete I ever played with.

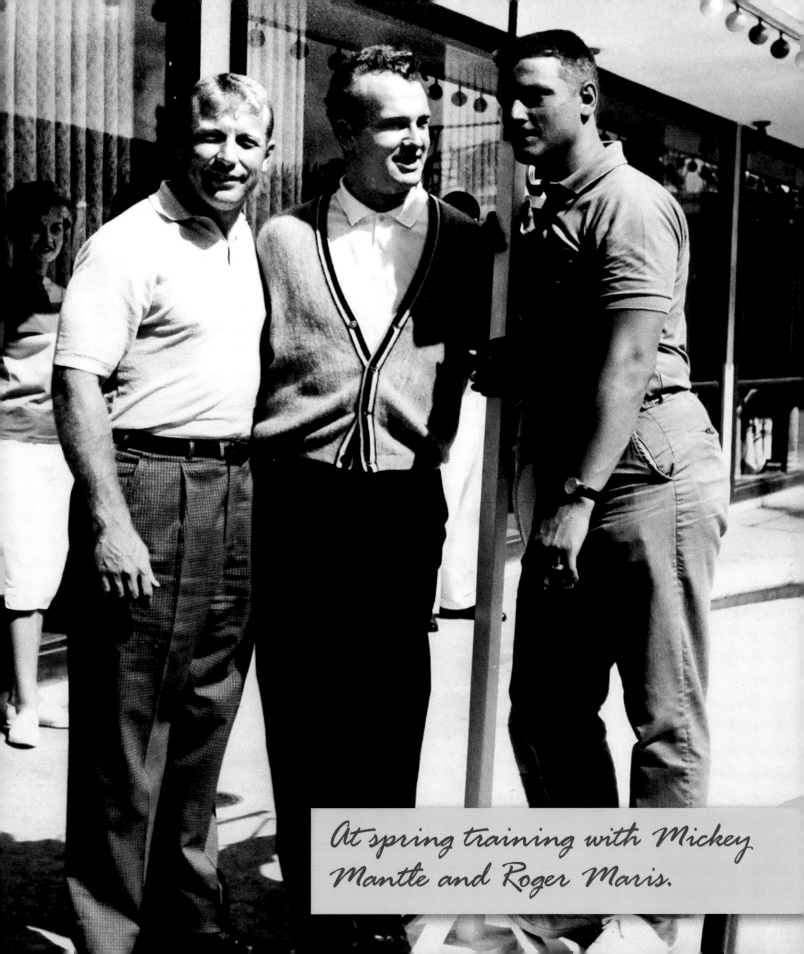

At spring training with Mickey Mantle and Roger Maris.

I remember I tried so hard to date Marilyn Monroe. She had divorced Joe DiMaggio and I was really interested in her. A friend of mine was able to get her phone number and I'd call her all the time but she was never there. I remember we finally connected and we were supposed to meet on a street corner in Hollywood and she never showed up. I was more than a little disappointed.

But I also knew I had to figure out my future in pro football. I knew I wasn't happy with the direction we were going in Green Bay. McLean at least had settled on me as a fullback but I still wasn't sure where we were headed. After all, I wasn't even the starting fullback anymore. I really didn't know what was going to happen.

Then Ray McLean made the decision that would change my life and the fortunes of the Packers—he resigned as head coach after just one season. I really did like Ray and he has been terrific as an assistant coach, but sometimes guys who make great assistant coaches have no idea what to do when they're in charge. That was Ray.

The name that kept popping up as the new coach was an assistant coach from the New York Giants, some guy named Vince Lombardi who had never been a head coach before but who seemed to have a great reputation. The Packers executive committee apparently had a list of about 20 guys who they were considering for head coach but the name everyone kept coming back to was Lombardi.

The day he was hired, my mom called me and asked what I knew about him and I told her not much, just that he had a really good reputation.

Tough, smart, and driven, he seemed to be exactly what we needed. The year before he had turned down the head coaching job of the Philadelphia Eagles and now he was interested in the Packers and I thought that was interesting.

I remember he called me a few days after he was hired and said he was looking forward to meeting me and I could already tell in that phone and a few letters that he sent me in the off-season that he wanted me in great shape. And I also got the sense then that I was going to play a big role in what the Packers were going to do and that really got me excited. My first two years in the NFL just hadn't been a lot of fun and I was beginning to think that I didn't need the game as much as I thought I did.

I was ready for a change and this seemed just like the change we needed.

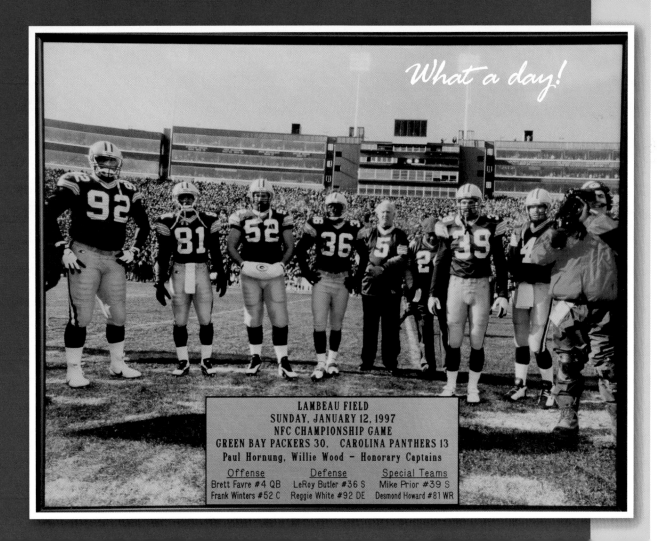

What a day!

LAMBEAU FIELD
SUNDAY, JANUARY 12, 1997
NFC CHAMPIONSHIP GAME
GREEN BAY PACKERS 30, CAROLINA PANTHERS 13
Paul Hornung, Willie Wood - Honorary Captains

Offense	Defense	Special Teams
Brett Favre #4 QB	LeRoy Butler #36 S	Mike Prior #39 S
Frank Winters #52 C	Reggie White #92 DE	Desmond Howard #81 WR

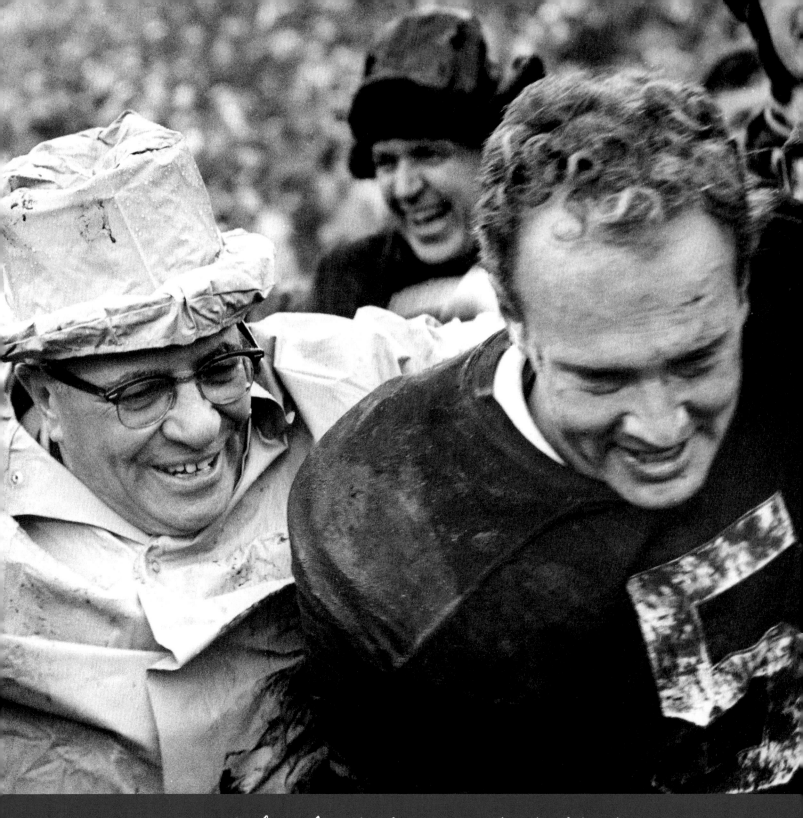

Me and Lombardi leaving the field after we beat the Cleveland Browns 23-12 in the 1965 NFL Championship Game.

Me and Lombardi

There is a letter on the wall of my office that still means a lot to me and I think goes a long way toward showing just what kind of person Vince Lombardi was and what he expected of people.

May 1959

Dear Paul:

Congratulations on your fine performance in the Notre Dame "Old Timers" game last Saturday. I was very pleased to hear of your fine performance, and am looking forward to being associated with you in Green Bay this fall.

I would like you to report to Green Bay on Monday July 13, 1959. With the installation of a new system for the Packers, it is imperative that we get off to a good start and I expect you to report in top physical condition. We will start running immediately and I suggest that you report to training camp at a maximum of 207 pounds.

You will be heavy enough at that weight and the left halfback in my system must have speed in order to capitalize on the running pass option play.

Looking forward in seeing you in July. I am.

Sincerely,
Vince Lombardi, head coach and general manager

A letter from Vince Lombardi to Paul Hornung – May 1959

Dear Paul:
Congratulations on your fine performance in the Notre Dame "Old Timers" game last Saturday. I was very pleased to hear of your fine performance, and am looking forward to being associated with you in Green Bay this fall.

I would like you to report to Green Bay on Monday, July 13, 1959. With the installation of a new system for the Packers, it is imperative that we get off to a good start and I expect you to report in top physical condition. We will start running immediately and I suggest that you report to training camp at a maximum of 207 pounds. You will be heavy enough at that weight and the left halfback in my system must have speed in order to capitalize on the running pass option play. ...

Looking forward to seeing you in July, I am,

Sincerely,
Vince Lombardi
Head Coach and General Manager

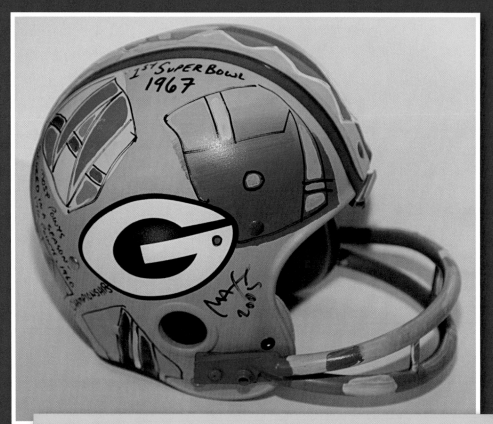

A Packers helmet painted by Peter Max for the first Super Bowl.

I wasn't sure what to make of that letter at first but before long I understood just how serious he was about turning the Packers around.

He had only been named the Packers coach three months earlier but you could already see the wheels were turning, the system was in place, and he had a vision for what his new teams would be.

I wasn't sure it was going to work at first because I had already been in Green Bay two seasons and had two different coaches and I was starting to get a little frustrated.

Remember, they had no idea what to do with me my first two years and I didn't do much. Blackbourn and I didn't really get along and Scooter McLean was just so unprepared for what he needed to do. I had played quarterback, running back, fullback, and there was even some talk of moving me to defensive back and that would have just fine. I knew I

didn't have the arm to be an NFL quarterback and while I was happy to play fullback, that wasn't really my position either. I was even benched the last couple games of my second season and was replaced by a rookie from LSU, Jimmy Taylor. I couldn't really argue either, Jimmy was a hell of a player.

In those first two seasons, the Packers were just as awful as they'd been the previous 10. We were 3–9 in my first season in 1957 and it got even worse the next year when we went 1–10–1, still the worst record in franchise history. I didn't know what the hell I'd gotten myself into.

I was so upset and frustrated that I even considered retiring and pursuing an acting career. I'd had some offers and I was already endorsing products and I thought I could be pretty good at it if I committed to it. I know Jimmy Brown, that great back from Syracuse who went on to play for the Browns and is still the best back I've ever seen, talked about it. He eventually did walk away from football at the height of his career and never looked back. So I did think about it, but not for every long. I started this and I wanted to see where it would go with Lombardi.

Here I am with Max McGee (far left) and Billy Kilmer (far right).

All I really knew about him was that he was the offensive coordinator of the New York Giants. He had a great reputation. I remember our quarterback Bart Starr knew that Lombardi was tough and demanding, recalling a game the year before when Lombardi, who ran the Giants' offense, screamed at the Giants defense when it came off the field after giving up a touchdown. Bart said he always remembered that and remembered what a tough guy he was. And I think we needed a tough guy.

I knew there were coaches around the NFL who thought Lombardi was going to be one of the next great head coaches in the league. There's a story that Chicago Bears head guy George Halas talked to Packers president Dominic Olejniczak and cussed him out for hiring Lombardi because now the Packers were going to be a team to deal with again. I'm not sure if it's a true story but I'd like to think it is.

I reported to training camp that summer in the best shape of his life, running the steps at Lambeau Field and hoping against hope that my third season in the NFL would finally make a difference. I was running out of time and patience.

I could tell almost immediately that changes were coming because Lombardi knew exactly where I belonged in his offense. There was no question and no doubt and if it didn't work out, it was either because I didn't work hard enough or he didn't coach me well enough. That was exciting.

I was a running back and I would be the featured running back in an offense that ran the ball hard all the time. But it wasn't just me that he put in position. Remember the Packers of 1958 who won just one game had a bunch of great players, many of who would end up in the Hall of Fame? There was Jimmy Taylor, Forrest Gregg, Ray Nitschke, Bart Starr, and myself, and it was a team ready to cut loose with the right leadership. In Lombardi, we found it.

In my first season under Lombardi in 1959, I basically doubled my offensive output from my first two seasons. My first two seasons, I ran the ball 129 times for 629 yards. In 1959, as the featured halfback, I carried the ball 152 times for 681 yards and seven touchdowns. That was what I was looking for and what the team needed.

I'll never forget when Lombardi said, "You're going to be my left halfback and if you can't play halfback you're not going to be in the league." I liked that.

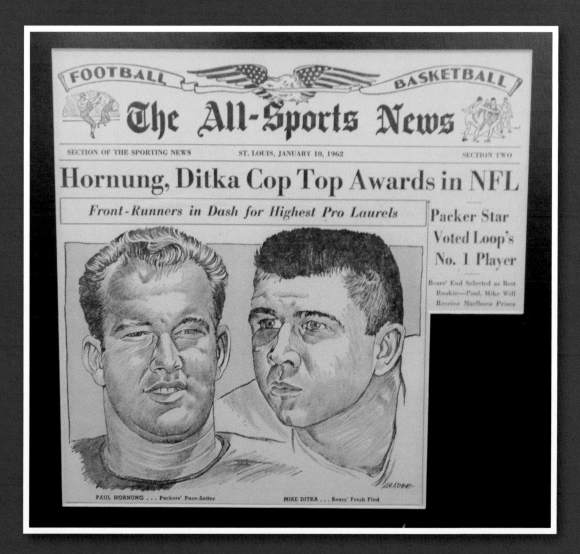

FOOTBALL — BASKETBALL

The All-Sports News

SECTION OF THE SPORTING NEWS ST. LOUIS, JANUARY 10, 1962 SECTION TWO

Hornung, Ditka Cop Top Awards in NFL

Front-Runners in Dash for Highest Pro Laurels

Packer Star Voted Loop's No. 1 Player

Bears' End Selected as Best Rookie—Paul, Mike Will Receive Marlboro Prizes

PAUL HORNUNG . . . Packers' Pace-Setter MIKE DITKA . . . Bears' Frosh Find

We had that first meeting with Lombardi and I remember Bart said, "Everything is going to change," and he was right, everything did change. Lombardi proved that right away because he also told Bart, "You're going to be my quarterback."

He told me "You're not going to have to worry about where you're going to play each week." He defined my future. That's what I really needed. I needed a way to go.

I knew there was going to be a change around here. First of all there was going to be discipline. The way we lived and practiced, the way we went about the whole situation. We were going to do it his way and we felt that right away. We knew we had a chance to improve immediately and we did. We had enough talent to do it that year.

I mean, we had a Hall of Famer at center in Jim Ringo. People don't realize how good he was. He was the leader of the offensive line along with Forrest Gregg. Bart had a great year. The offensive line really protected him and the offense started to come of age. Jimmy had a great year at fullback. I had a pretty good year. The Packers that everyone came to know were born with Bart and Forrest and Fuzzy Thurston and Jerry Kramer and probably the best blocker of all time, tight end Ron Kramer. Kramer was one of the greatest players I ever played with.

He was just one of the great athletes at Michigan. He had great hands and was a great blocker. I remember one time he told me that the track coach at Michigan asked him if he'd ever high jumped before. Kramer said no and the coach asked him if he wanted to try it. So he went out and broke the Big 10 high-jump record. He came to 50 Kentucky Derbys with me. He always said, "I hate the horses but I come down here to have fun." He was one of my great friends and I miss him a lot.

I knew Lombardi liked me and the way I ran. I think he saw me as the short-yardage runner that was going to be needed in his offense and I was happy to do whatever needed to be done.

That first season, you could already tell everything was different. We approached games differently, nobody dared challenge Lombardi and his authority and he made us believe in ourselves.

He not only made a great impression on you but he was a strict man. He made us believe it was the right way, the best way to win. He said, "We're going to operate this way because I feel it's the best way to win." And when you get all your players thinking that way, you've got

an edge. He made us believe we were that good. He saw the talent we had and realized we had the opportunity to do something special. His job was to make us believe he could do it, and he did.

Did I worship Lombardi? I wouldn't use the word worship. I admired him very much. I thought he was the best coach I could have ever had. And he was right all the time. He's the only coach who was always right. The only mistake I thought he made was this one time with Ray Nitschke.

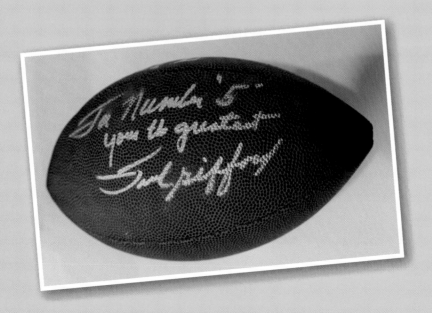

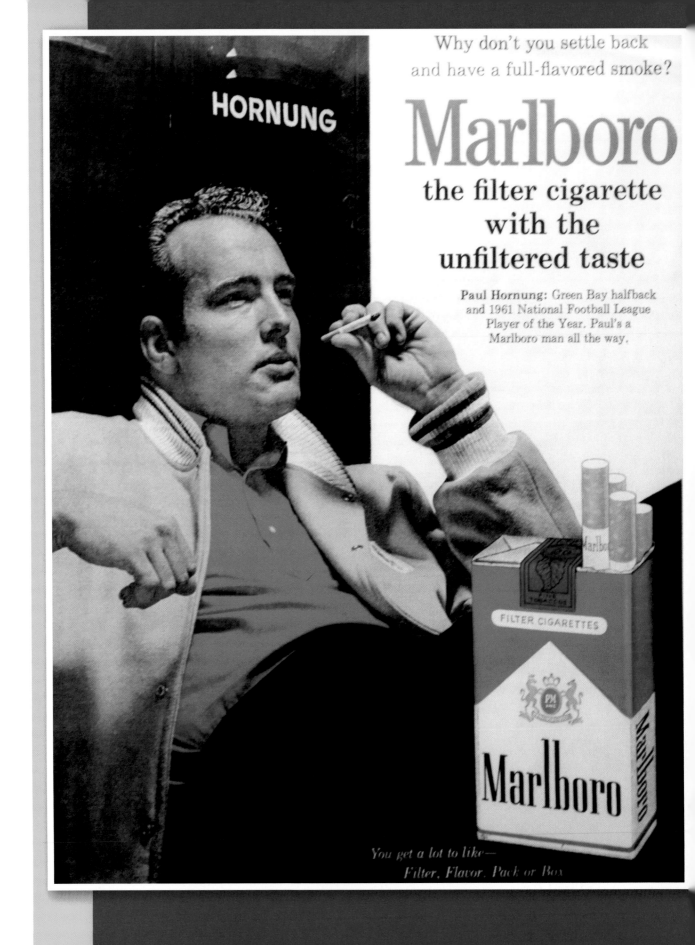

Nitschke broke the rules the night before that first Super Bowl in Los Angeles. We were sitting in the team hotel bar and the coaches happened to show up too so the big dummy sent them over some drinks. That was a no-no for Lombardi's boys. He shouldn't have been in the bar and he really shouldn't have sent Lombardi a drink.

I don't know why the coaches were even there since that was a player's bar. But there they were and Lombardi went up to him and said, "You're suspended. I want you on a plane back to Chicago."

I don't know what he could have been thinking. Lombardi was furious so he decided to suspend Raymond for the biggest game of the season. If it was me in that situation, I don't know what he would have done. Yes I do—he would have suspended my ass. But he reneged on his principles. He went against it.

The next day at the team meeting he said, "Maybe I was a little rash and I think I'm going to let you all vote on it." Now he had never put anything up to a team vote before and I don't know why he was doing it this time

and I wasn't happy about it. So I said, "Screw him. I think he should be suspended. Send his ass back to Chicago." The rest of the team howled with laughter. They didn't think I was serious, but I was.

Lombardi, naturally, wanted him to play because he was still one of the best linebackers in the game. Him and Dick Butkus, they were best. But if I had done the same thing Raymond had done, there's no telling what he would have done. So the team voted to let him play and I knew they would. I didn't. So Lombardi went with the team vote and let him play and that was the only time I ever saw Lombardi go back on his principles. I still don't know why he did that.

I always felt that was the only thing he ever did against his will as the Packers coach. He was not Vince Lombardi in that moment and I never let him forget it either. I talked to him about it all the time too. He probably talked to Phil Bengtson, the coach of the defense and the time, and Phil probably said, "We need him."

We didn't have that many healthy linebackers for the game and Raymond had a hell of a game. But he was never one of my favorites.

Nitschke could be a complete asshole. But it was usually when he drank too much. I remember how he'd get in fights with bartenders. There was a time in Milwaukee when he grabbed one and pulled him over the bar. It's a wonder he didn't get killed in Milwaukee.

That was a strange week. They didn't call it the Super Bowl then, of course, it was the NFL-AFL Championship Game, I think. Anyway, it was nowhere the big deal then that it is now. It's crazy now. Still, we knew what was at stake and you can bet Lombardi did too. I mean, we were the Packers, the best team in football. I guess you could say we were a dynasty at that point and nobody expected us to lose to those guys from the AFL.

I was hurt so I wasn't going to play anyway but I knew how much this game meant to Lombardi. He knew, and I think all of the players knew too, that this was almost a no-win situation for us. We were expected to win, and win big.

If we did win by a lot, then so what? If we didn't, then we'd get a lot of criticism. And if we lost, oh my God, the thought of that was too much for any of us, especially Lombardi, to think about. I'm not sure I'd ever seen him more nervous before a game than I did in that game against the Chiefs.

But I really wasn't concerned. There weren't too many teams you could look at in those days and say they were better than the Packers. We had more All Pros than anybody in those days. I just didn't think anybody could touch us and certainly not any teams from the AFL. The Chiefs were a nice team and they had an old friend of mine at quarterback, Lenny Dawson, but they couldn't compete with us. I thought we were a cinch to win.

I remember the professional golfer Bob Rosburg was a friend of mine and the week before the game he said that her knew a guy down in Texas who loves to bet and he's a big AFL fan. I knew I wasn't going to play because I had a neck injury and I told Rosburg to tell that guy we'll be a big favorite and I said this is the cinch of the year. I didn't bet anymore but I knew if you were going to make a bet, that was the game. We were a cinch and I knew it. And we won easily.

I remember Jimmy Taylor had a hell of a game that day and so did Bart. Actually, so did Nitschke, even though he never should have played.

I was the only player on the field that didn't get in the game. In the third quarter, Vince called me over and said, "Do you want to go in the game for a few plays? We can throw you a swing pass." I said, "No coach, I don't want to do that." I didn't want to go into a game like that. Did it ever bother me not getting into a Super Bowl? No, it didn't because that didn't feel like the right way to do it. I didn't want to make an appearance and leave again. That wasn't right. But even then, I think Lombardi understood the significance of the game and what it would be down the road. Maybe he knew this was my last chance to play in a Super Bowl. I didn't know that then, but it would be my last chance and I'm okay with that.

Bart Starr and me at Lombardi the play in Milwaukee.

Bart was named the MVP of that game, but it should have gone to Max. He had a hell of a game and if Lombardi had known what he'd done the night before, he never would have played. Max, after all, wasn't Nitschke.

I think everybody's heard the story about Max the night before the game. It's a great story and pure Max. God, he was a hell of a guy. He was out the night before the game and that morning but Max didn't get caught because, for some reason, coaches didn't take bed check that night.

I was his roommate—we'd been roommates for years—and here's the odd part of that story. I was going to get married on the Monday after the Super Bowl. I was going to marry Pat Roeder, who was from Green Bay. We were going

to get married in Los Angeles and then go to Honolulu after the game. McGee went out Saturday night and found two ladies and he said he wanted me to come out with them. I said, "Man, you're nutty. I'm getting married Monday, you dummy." He came in that morning and asked if they'd taken check and I said, "No, you lucky bastard." If they had checked, he would have been suspended. Lombardi actually saw Max in the hotel lobby that morning but never knew anything was going on. He was a lucky bastard.

After that first Super Bowl, Max became a star. He'd be more honest with his thoughts than anybody. He knew when he was going to have a good day. He was a great student of the game; really smart.

He knew he could get open against Kansas City and he came back to Bart and said, "Watch for me, they're not covering me." He really should have been MVP in the first Super Bowl. I think Bart will agree with that.

Here's another Max story. I remember after the game, I was scheduled to play in the Bob Hope golf tournament in Pam Springs but I was getting married on Monday, so I told the organizers I wasn't going to be able to make it.

Max was at a funeral and he said, "Are you going to play in the Bob Hope golf tournament?" I told him I couldn't make it so he said, "Can

you get me in?" After how he played in the Super Bowl, everybody knew who he was by now. So I called the Bob Hope group and said "I can't play but Max McGee would like to substitute." And they said they'd love to have him and Max was so excited. He was a really good golfer but he hadn't played in four or five months. He wasn't up to snuff but he picked up his clubs and went because he'd always wanted to play there.

He played with dancer/actor Donald O'Connor and they led the tournament after the first two days. They didn't win but did he have a great time. He talked about that for years afterward. He's the best putter I've ever played against.

He was going to meet me in Honolulu after my wedding. That's just the way he was. He was a very talented guy. He could do anything. He was one of the greatest poker players I've ever seen. And a great gin player. We made a lot of bets together but he didn't get caught in the trap that I did, thank God.

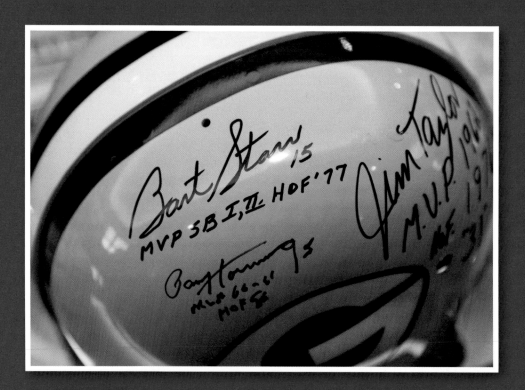

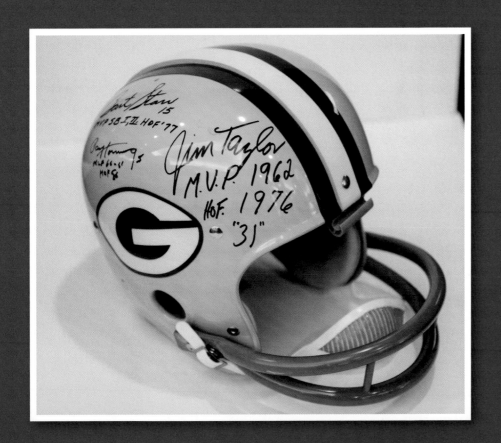

I miss Max so much. He died in 2007 from injuries suffered in a fall while removing leaves from the roof of his house in Minnesota. What he was doing on that roof, I still don't know. What the hell was he doing up there? He should still be here. I'm still so damn mad at him.

And then there's the time he was going to buy me dinner to celebrate my wedding at a really nice restaurant in Beverly Hills. The bill comes and it's a lot more than he expects so he decides to write a check and it's no good. He eventually persuades the owner to let him pay with a check and he'd make it good because he'd just had a great game against the Chiefs in the Super Bowl. But of course, he never did. He paid for my wedding dinner with a bad check. That was Max. That was his M.O. He was the best.

There's a photo on my wall of Max, myself, and my other great friend from the Packers, Fuzzy Thurston. I don't remember where it was taken but I remember just about everything else about it. Poor Fuzzy, he's got Alzheimer's now.

It was 1969 and there was a big farewell party for Lombardi. He had just accepted the general manager and head coaching job with the Washington Redskins. They gave him a hell of deal and he couldn't turn it down.

I'd already been retired for two seasons but I think everybody who had played for the Packers in his years there was at the party. It was a hell of a time. It was a very emotional night. I was still a Green Packer and I knew I always would be. Fuzzy, Max, and I got up sang "He's Got the Whole World in His Hands," and he really did. It was quite a party, but we were all very sad because we knew an era was ending.

In Las Vegas for a signing.

I think we all knew something was changing a year earlier when he gave up coaching and kept the general manager duties. I didn't think he'd be happy doing that but I wasn't going to tell him that. Phil Bengtson was Vince's defensive coordinator and a good coach but I wouldn't have wanted to be the guy taking over for a legend like Vince Lombardi. And he was already a legend by that point.

Phil never really had a chance. The core of those championship teams was changing. Players were getting older and retiring. Hell, Jimmy Taylor and I were both left unprotected in the expansion draft in 1967 and both of us were taken by the New Orleans Saints. There were 11 Packers left unprotected to help stock that new team. Can you believe that? That says something about what kind of team we had.

Anyway, maybe Vince could see an era ending too and maybe he didn't have the patience and energy to rebuild a team. After all, he'd already been in Green Bay nine years and sometimes when a coach has been around that long, sometimes players have a tendency to stop hearing the message.

I had tried to talk Lombardi out of quitting because a lot of us knew he wouldn't be happy in a role where he wasn't in charge. That's what he did best. He was still the general manager and in charge of bringing players in but he wasn't coaching those players anymore, and that's what made him go.

The Packers were changing and Lombardi could see it and couldn't do anything about it. I heard about how he'd walk around the practice field, the place where he did most of his teaching, knowing he really couldn't step in and make suggestions. He had given the team to Phil and he had trust him to do the job, but we all know how Vince would have done it so differently. It must have been terrible for him.

I guess you know that Lombardi's press box was sound-proofed because on game days, he would go crazy, screaming at players and calls and how his team was playing. But at least the media guys couldn't hear him. It was a smart decision because I can only imagine what was coming out his mouth. He had to be so frustrated. The Packers went just 6–7–1 that season, Green Bay's first losing season

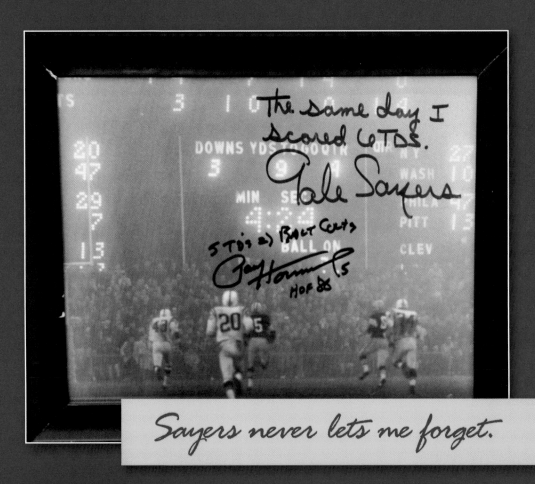

Sayers never lets me forget.

since 1958. I'm sure Vince felt responsible and angry and helpless and maybe that's when he decided he still had something to offer as a head coach.

I'm sure Lombardi thought after that season that he'd made a mistake by quitting as head coach, but I'm sure he had his reasons. I never really asked him why he decided to come back, and with the Redskins of all teams, but I knew he probably saw in them a team a lot like the Packers team he took over when I was there.

Edward Bennett Williams was the owner of the Redskins and a very smart guy. He knew he had to turn his franchise around too and what better way to do that than with the best coach in football. I know they made him a great offer and he couldn't turn it down. It not only made him the general manager and head coach, but a part owner as well. I know Vince had designs on someday being NFL commissioner too. I think he would have made a great commissioner.

I know how much he admired Redskins quarterback Sonny Jurgensen. He loved Jurgensen. He thought he was really special and he was. He had such great accuracy and I don't think he thought there was anybody in league that could touch him. He told us if he'd had Jurgensen in Green Bay we might not have ever lost a game. I took that as a shot against Bart, but I didn't argue.

Maybe he saw in him the same potential that he saw in me 10 years earlier when he thought he could turn the Packers around with a great running game led by me and Jimmy Taylor. It worked in Green Bay, so why couldn't it work in Washington.

And while I was happy to see him back doing what he did best, I couldn't help but wonder if the situation might not have been a little different. It might have changed college football forever.

I knew he still believed he could coach and that's when I talked to the athletic director at Notre Dame. I was doing color commentary for Notre Dame football with Lindsey Nelson and I told Dick that Lombardi would love to be the head coach at Notre Dame.

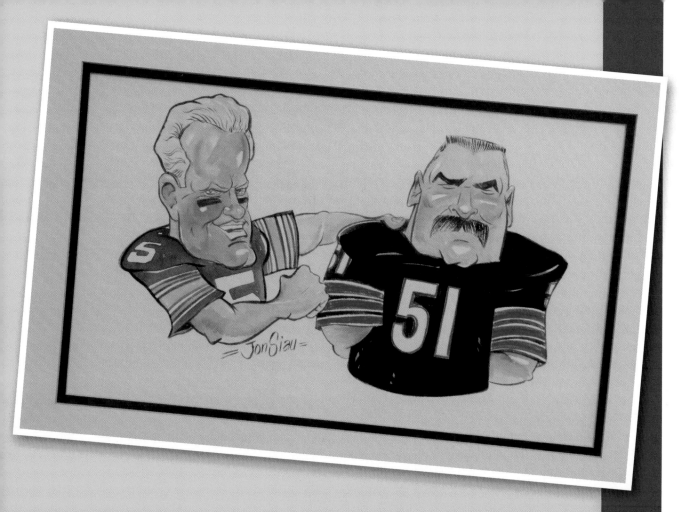

Ara Parseghian was the coach there and he was a great success but I'd heard he was having some health issues and wasn't sure how much longer he'd coach. I told Dick that if he offered the head coaching job to Lombardi, he'd take it. Can you imagine Vince Lombardi, a devout Catholic who got his start coaching at Fordham University, coaching at Notre Dame? Jesus, he would've been great. But whoever was in charge didn't even call him to find out if he was interested. I really wanted Notre Dame to grab a hold of him. I thought he'd be perfect for Notre Dame. It would have been a marriage made in heaven. But no one contacted him. Ridiculous.

Looking back, Lombardi and I got along great. I respected him and I think he respected me. He was close to my mom. He'd always invite her to his house for cocktails and he invited me a few times, but I felt out of place.

Even after I retired, we stayed close. Lombardi said he wanted me on the sidelines with him for the second Super Bowl. So I went down to Miami for the game. Why not? I was single at that point, my marriage to Pat having lasted barely a year. He said, "I want to you on the sidelines and if you see anything you like, tell me." I watched the game but I didn't see anything.

It was the same the year before during the Ice Bowl game at Lambeau Field. Jesus Christ was it cold. I don't care what they say about games today, I'm not sure it will ever be colder than it was that day when we played the Dallas Cowboys. That game should have been postponed. I have no idea why it wasn't.

I was standing next to Lombardi nearly the entire game and he did the same thing, asking me if I saw any plays I liked to let him know. I never did because you didn't really tell Lombardi anything. At the time I said "No sir, I don't." I wasn't going to tell him anything because I thought he might run the damn thing. I was standing right there on that fourth down call when Bart said that a quarterback sneak would work. He said, "Run it and let's get the hell out of here."

Everybody knows he said that today but that was a big deal back then because it showed just how much confidence he had in Bart. He was a great

Me and my beautiful wife, Angela.

quarterback, and he's always been underrated. But I thought that was a good call too. I don't think in all the years I was with the Packers that we were ever stopped on the 1-yard line.

After the game I was supposed to do an interview with Pat Summerall. It was 32 below and after standing there all afternoon, I was frozen and couldn't talk to him. I couldn't do the interview because my jaw was frozen. I mean it, really frozen. It was one of the few times I was at a loss for words. But Pat couldn't talk either. We were all frozen so they just canceled the interview. That was very strange.

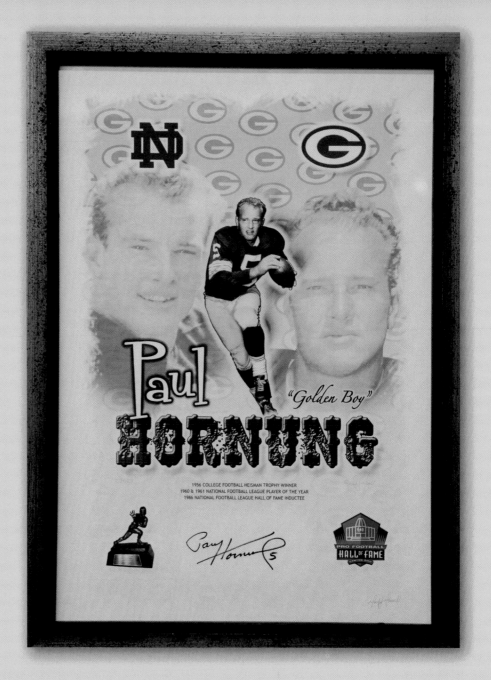

I just remember so many big games and Lombardi always had us ready. It's funny, so many people remember when we beat the Bears in the season opener of the 1959 season, Lombardi's first game as head coach. It was a nice but apparently a few players carried him off the field. I thought it was a little early to be doing things like that. There are always new guys who try to do stuff like that and it doesn't make a lot of sense. We did go 7–5 and it was Green Bay's first winning season since 1947 and that was great but we still had a long way to go.

That next season, we made it to the NFL Championship Game against the Eagles at old Franklin Field. We were kind of overmatched and the quarterback for the Eagles, Norm Van Brocklin, had a hell of a day. Though this was Green Bay's first championship game appearance since 1944, there was a part of me that that still thought we had the better team. I mean, this was the same team, basically, that would win five titles over the next seven years, but I guess you have to start somewhere.

That Eagles team had some nice players too, of course, with Chuck Bednarik, Tommy McDonald (who'd I'd beaten out for the Heisman Trophy a few years earlier), Pete Retzlaff, and Van Brocklin. He was a hell of a player and probably the main reason Philly had a chance at all. He was named the game's MVP after throwing one touchdown pass and for like 200 yards, but I think Bednarik deserved it.

We gained more yards than they did but they also stopped us on some big plays, including the last play of the game, when Jimmy Taylor was tackled at around the 10-yard line and Bednarik, the bastard, wouldn't let him up until the clock had run out. That was a smart play by a great player.

The loss hurt, I won't lie. I played okay, I rushed for about 60 yards and kicked two field goals, but to have gotten that far and lost really stung. It especially hurt because of where this team was just a couple of years before.

One thing I remember is how we were stopped a few times on fourth down deep in Philly territory. After the game, Lombardi took responsibility for those calls. He said he should have kicked field goals and gotten something out of those drives, but he chose not to. He said he lost the game, not the players. That really showed me something about him as a coach and a man.

He also said something else that stayed with me and the rest of players. That's when he made his famous statement that we'll be back in this spot again and we won't lose again. And we didn't. We believed it. And we won five titles after that.

People ask me all the time which of those championships was the best and I don't have a great answer. They were all great teams but, for my money, that 1961 team, the one that destroyed the Giants in the NFL title game, might have topped them all.

We won that game 37–0 and I had a great game, maybe one of my best as a pro. And the funny thing is, I almost missed it due to my military obligations.

It was a strange time then since nearly every player had to fulfill some military obligation and I was no different. I was going to go into the Air Force but my mom told me to go into the Army so I could be stationed relatively close by at Fort Riley, Kansas. I knew I had some service ahead and I was all right with that. In fact, I was supposed to do two years of service

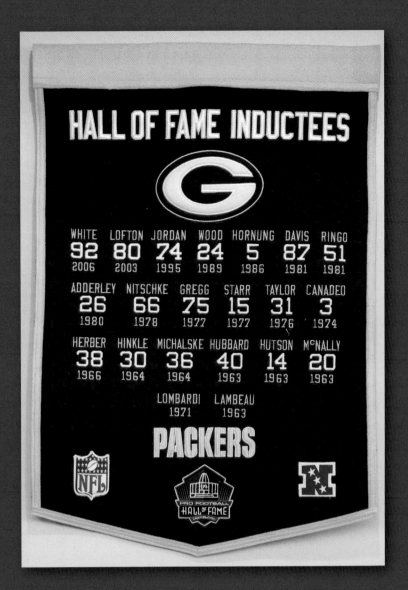

HALL OF FAME INDUCTEES

WHITE	LOFTON	JORDAN	WOOD	HORNUNG	DAVIS	RINGO
92	80	74	24	5	87	51
2006	2003	1995	1989	1986	1981	1981

ADDERLEY	NITSCHKE	GREGG	STARR	TAYLOR	CANADEO
26	66	75	15	31	3
1980	1978	1977	1977	1976	1974

HERBER	HINKLE	MICHALSKE	HUBBARD	HUTSON	McNALLY
38	30	36	40	14	20
1966	1964	1964	1963	1963	1963

LOMBARDI	LAMBEAU
1971	1963

PACKERS

but I ended up only having to do six months as a truck driver and radio operator.

I had a recurring neck injury that should have kept me from any kind of service and when I flunked my Army physical, I think it was in November that year, I figured it was over. But the Army called again a week or so later and I had to report to the Great Lakes Naval Training Station outside Chicago for another physical that I figured I'd flunk again.

But I remember this Army doctor told me that I could take care of my service now, "Or they'll keep sending you around the country until you pass." I decided to take care of it then and there.

I was having a hell of a season. I was leading the league in scoring for the third straight year, including one game against the Colts when I scored four touchdowns and kicked six points-after for 33 points, still a Packers record for a single game, I think. That's the year I was named the NFL MVP. It was just a great year that I really enjoyed.

I knew I was facing my service obligation and, officially, I was supposed to get a six-day pass the second week of January, which meant I would miss the championship game against the Giants. I asked my captain at Fort Riley if I could switch it to the week of December 27 to January 3 so I could play in the game. But the SOB wouldn't let me. I didn't think it was that big a deal, but I guess he did. I didn't know what to do.

And we had a tremendous team offensively. I was really in a great position in that offense. I was in clutch situations, catching and running the ball. We were actually underdogs in that game and it was played in Green Bay, the first time a playoff game had been played there. It was also nationally televised so, of course, I really didn't want to miss it.

I knew this was a very important game for Lombardi. More than anything he wanted to beat the Giants because he'd coached there and he had a relationship with the Mara family, who owned the team.

When I told Lombardi that I wasn't sure I could get away, I figured it was all over. But Lombardi had met President Kennedy and they really hit it off. They really admired each other. Kennedy actually gave Vince his private phone number and told him to call if he ever needed anything.

So he did and apparently the captain who had denied my pass request got a call from the president of the United States. Before I knew it, I was on a plane back to Green Bay. Can you believe that?

I didn't know what happened at the time and Lombardi didn't tell me what he was doing but I'm glad he did because I had a great game. I ran for 89 yards, scored a touchdown, kicked three field goals and four extra points, and set an NFL playoff scoring record with 19 points in a 37–0 win and the Packers first NFL title since 1944 and seventh in team history.

It was as complete a performance as I can remember and Lombardi was really choked up after the game, calling us the best team in NFL history. I couldn't disagree.

I was named the MVP of the game and won a Corvette. I picked up the car in New York and drove it to Fort Riley. I was delighted to be that successful. We had a hell of a football team. That Giants team was a great defensive team and we kind of manhandled them.

The Giants were so mad at having been embarrassed by us that they spent the next season making sure they faced us again in the championship game. We were 13–1 that season, I think we only lost to Detroit on Thanksgiving Day, and we were loaded. We had a hell of a team again. Maybe that was our best team because we had no weaknesses on offense or defense.

I was having some injury problems, including a bad knee, but Jimmy Taylor really took off as a fullback. Man he played well that season. I think he gained over 1,000 yards. Jerry Kramer also took over kicking field goals, even though he wasn't all that comfortable doing it.

So we did face the Giants, but this time it was at Yankee Stadium, and damn was it cold. Windy and cold and miserable and Taylor said he'd

never had as much trouble getting his footing as he did that day. And neither of us remember being hit as hard as we were that day. It was a nasty game.

But when you're having a good game, you don't worry about the weather. Jimmy had a hell of a game. He had a great day on a bad field, scoring a touchdown and running for almost 100 yards. And Kramer, that SOB, he kicked three field goals in some of the worst wind you can imagine. We were a very good poor-weather team. When it was poor weather, we could play. That's important for great teams to be able to play on all fields and we were very good at that. It didn't matter what kind of field we played on because we knew what we could do.

That was two championships in a row and we didn't see any reason we couldn't make it three in a row. We were at the peak of our game and we saw no end in sight. But, and I'll never forget this, I was in Los Angeles in January and I was having dinner with Bart Starr, Jerry Kramer, and Jimmy Taylor and their wives. During dinner, I got a call from Commissioner Pete Rozelle and he wanted me in New York for a meeting as quickly as I could get there.

Did I know what it was about? Yeah, I had a pretty good idea.

MAY 20, 1963 25 CENTS

Sports Illustrated

THE
TRUE
MORAL
CRISIS
IN
SPORT

UNEMPLOYED FOOTBALLER
PAUL HORNUNG

CHAPTER 5

Life in Limbo

My second time on the cover of *Sports Illustrated* wasn't exactly what I was hoping for. It's got my picture on the cover and says "The True Moral Crisis in Sport" and it's dated May 20, 1963. That's not exactly the reputation I was hoping for but sometimes you have to accept what happens and move on. And that's what I did. I really didn't have much of a choice.

I guess gambling was really a problem in sports and the NFL was no different. And I did gamble. It was always just for fun because I was making pretty good money with the Packers and had a bunch of endorsement contracts too. I was the Marlboro Man for a few years. I did Jantzen clothes and Chevrolet, so it was never about the money for me. I just enjoyed it.

But there had been some pretty bad betting scandals over the years in sports, with instances of point-shaving and players throwing games to make money. There was the possibility of Mafia involvement and no one wanted to get

My good friend Jerry Bailey, the great jockey.

No Oscar? Why not? My experience in the movie business.

hung with that. I could see how it was an issue but, again, I never really thought anything about it. I did it for fun.

My guy was Barney Shapiro, a good friend of mine in Las Vegas. I made most of my bets through him. I never called a bookmaker in my life. Barney was a great guy, had a great sense of humor. He made his money on pinball machines in the San Francisco area and then he moved on to Vegas, where he owned nearly all the slot machines in Nevada. That's a lot of slot machines. He also invented the electronic blackjack machine and put them all over in the state. They were everywhere.

Anyway, we always talked about football and which teams I liked. Sometimes he'd take my advice and sometimes he wouldn't. It was no big deal to me. That started in the late 1950s and, again, I never thought that much about it. Just talk between two friends.

With Barney in Las Vegas, I'd ask him to put bets down for me and it was usually no more than seven or eight games a year and I never, ever bet against the Packers. Remember, we were awfully good then and we always seemed to beat the point spread so it never made a lot of sense. The biggest bet I ever made was $1,000 and I almost made a big bet on the first Super Bowl because I knew I wasn't going to play. But I didn't. That would have been really stupid.

So I went to New York to meet with Rozelle and I was quoted as saying, "It's one of the few times I went to New York and I wasn't looking for a date." That's probably true. I was nervous about the meeting because while I thought it had something to do with my gambling, I wasn't sure that was it. I mean, I'd always been around gambling. In Louisville, that's all you did and there were parlay parlors in bars all through Green Bay too. So it was hard to miss.

I remember meeting with the commissioner. It was very hush-hush. He didn't want anybody to know about it. So that wasn't a good sign either. I remember, I even had a drink with Mickey Mantle, who was staying at the same hotel I was, but he never asked me why I was in New York. I'm not sure what I would have told him.

So I met with the commissioner the next day and he asked me if I'd been gambling on NFL games and I said no. I shouldn't have said that because he said the league had been conducting an investigation for months and had tapped my phone in Green Bay. Can you believe that? That's so damned illegal, but at the time I didn't know that. I just knew I was in a lot trouble. A lot of people think I took a lie detector and passed but I never took the test, I told Pete I wasn't going to do it because I didn't want to implicate anyone else.

I told him I'd answer any questions he wanted about my gambling but that I wasn't going to name anyone else. I probably should have had a lawyer with me but I didn't. I can't remember if I decided I didn't need one or if I was just too stupid to bring one. Whatever it was, I knew I was probably going to have to take my lumps.

I did have my dealings with guys I thought were wiseguys but I never made bets with them and I certainly kept my distance. But, sure, I'd run into them at nightclubs and sporting events I went to. As I said, I just bet because I enjoyed it and there was really nothing to it other than that.

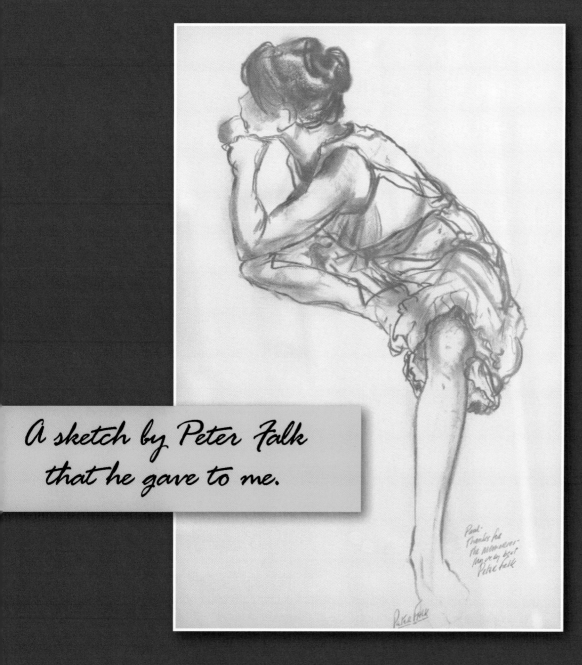

A sketch by Peter Falk that he gave to me.

But Pete Rozelle didn't see it that way. At the time, the NFL was growing in popularity but it had a fight on its hands with the American Football League, which was taking some of the top players with some pretty big contracts. He was concerned with the image and the future of the NFL, and he thought that any hint of scandal would be big trouble. I knew a lot of guys, and I mean a lot, who gambled pretty regularly though I don't know if they bet on their team to lose. But gambling was everywhere and I had a feeling I was going to be made an example of.

Painting of downtown Louisville by Tony Bennett.

Rozelle thanked me for coming and said he'd make a decision in a couple of months, but I already knew what that decision would be. And I was right. In April, he called me and said he was suspending me and Alex Karras, the defensive tackle of Detroit Lions, for gambling. What really bothered me was that he said the suspension was indefinite, which meant there was no guarantee when or if I'd play again. But he said he'd re-evaluate our cases early in 1964. That was a long year.

I felt bad for Alex Karras, a hell of a player on a really good Detroit defense. He never should have been suspended. He didn't do anything wrong except admit to playing parlay cards. That was nothing, but I think he panicked. Rozelle said he had evidence on him too and I think Karras wanted to do anything he could to get the whole thing behind him. That wasn't fair. Me? I really had no excuse. I still don't know what I did that was so awful, but I admitted to the gambling and took my medicine.

The toughest part was telling the two people who mattered to me most in the world—my mom and Coach Lombardi. Both actually took it pretty well. My mom said we've gone through tough times before and we'll do it again. Lombardi was disappointed that I didn't talk to him before the meeting to see if he could do something about it. I'm not sure what he could have done, but he's right, I should have told him. He told me to keep my nose clean, to stay away from the race tracks and Las Vegas, and he said he'd go to bat for me and get me back in the league the next year.

I remember there were all kinds of rumors that Lombardi was so mad at me that he was going to trade me. But he stood by me the whole time and denied to everyone that he had any intention of trading me. I believed him and that meant a lot to me.

That 1963 season, I went back to Louisville and got involved in my business interests with my partner and good friend, Frank Metz.

I was introduced to Frank through my cousin Henry, who was a like a father to me. Frank and I eventually got into the soybean business. Frank became very successful in the real estate business too. He passed away about 10 years ago. His wife Sandy is getting an award as one of the best business people in Louisville and Frank is the guy who taught her the business and he taught me too.

With the soybeans we make vegetable oil, and we formed the Louisville Edible Oil Company. Our first big contract was with Nabisco. Frank Gifford, the running back for the Giants and a great friend of mine, was responsible for getting me involved. Nabisco was our biggest customer. It made our company. Years later, we bought the Seagram's Distillery in Louisville, it's the biggest distillery in the U.S. We've sold it since then. In fact, we were just bought out by a big firm in Europe. I haven't been connected with the company for five or six years—since Frank died actually. But that's how I got my start in business.

That year, I also spent a lot time in Florida and it was tough staying away from the horse track because I enjoyed it so much. In fact, that suspension came down just a few weeks before the Kentucky Derby and I'd never missed a Derby. My teammate Ron Kramer always came down for the Derby and we'd spend a few days together, but I stayed away that year and it was hard. But it was a good decision. Can you imagine if I'd shown up at the biggest horse race in the country a few weeks after receiving an indefinite suspension from the commissioner of the NFL? I don't think I've missed one since.

They never said whether I could or couldn't go back to Green Bay that season, but I didn't. I only saw the Packers play once in person that year and that was a preseason game.

I remember not wanting to be noticed so I sat with Ron Kramer's wife and their two kids and I wore sunglasses. People still recognized me, though, and that was difficult.

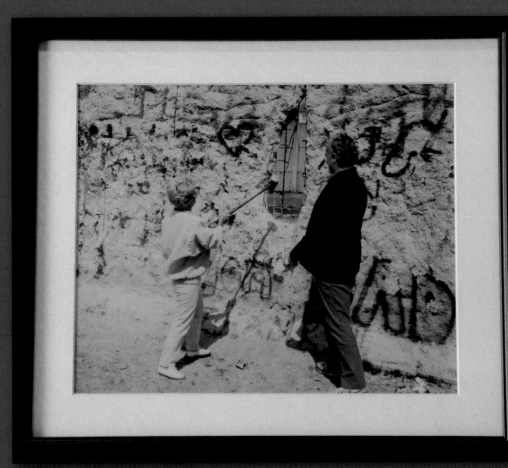

Angela and me tearing down the Berlin Wall.

I felt really bad about the suspension because we were at our peak as a team. We had been to three straight NFL Championship games and we'd won the last two and there was no reason we couldn't win a third straight. Now this whole thing had them in a bad situation.

That was a hell of a team too. Maybe one of the best we had, but that year the Chicago Bears were also pretty damned good. We lost to the Bears in the season opener and we lost to them again in November and those were our only two losses. We finished 11–2–1 but the Bears went 11–1–2 and won the division. They won it by a stinking half game and I always wondered, I still wonder sometimes, how different it would have been if I had been able to play.

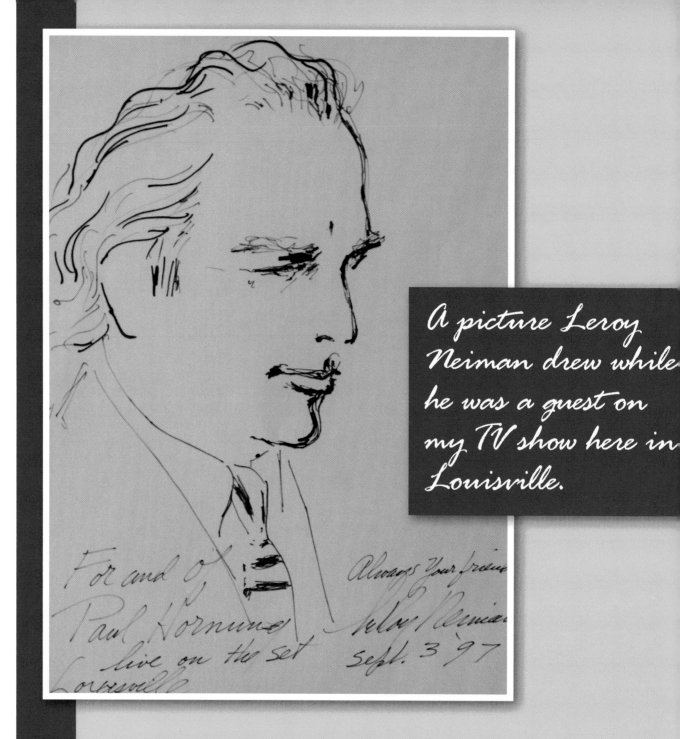

A picture Leroy Neiman drew while he was a guest on my TV show here in Louisville.

For and of Paul Hornung live on the set Louisville

Always your friend Leroy Neiman sept. 3 '97

Jimmy Taylor had another great season, rushing for more than 1,000 yards and nine touchdowns. Tom Moore, a really good back in his own right, took my spot and had a good season too. He rushed for like 600 yards and did a terrific job. But with me out, as well as Bart Starr, who suffered a broken leg that season, we just couldn't get over the hump.

I do remember that season was significant for one thing: I kept Rick Casares, the Bears' rugged running back and one of my great friends, from killing Ray Nitschke.

In the Packers second loss to the Bears in Chicago, Casares runs off tackle and Nitschke tackles him, twists his ankle and breaks it, putting him out for the rest of the season. Now Rick was my friend and one of the toughest bastards I've ever know and he was not happy about what happened. He thought Raymond deliberately broke his ankle. And while he was a great guy, if you got on Casares' bad side, you were in trouble.

So he was out for the season and he came down to Louisville and stayed with me for a month. And all the time he was there, he kept saying, "I'll get Nitschke, that SOB. I won't forget this."

And I believed him because I remember one night on Rush Street in Chicago, one guy made a comment about Casares' girlfriend and he hit that guy and I thought he was dead before he hit the ground. Then he jumped on that guy and hit him three times. He was the toughest guy I've ever known.

So he's saying, "If it's the last thing I do, I'll get that SOB." So the next spring, we had a 1,000-yard rushers dinner in Green Bay at Fuzzy's restaurant, The Left Guard, in Appleton.

There was a cocktail party the night before and Nitschke came in. He didn't know Casares was going to be there. He didn't even remember Casares, but Rick didn't forget. Rick's eyes got this big. He went up to Raymond and said, "Let me ask you something, Mr. Nitschke, will you step outside with me because I've got something to tell you." Nitschke didn't go. Rick put him down in front of his peers. He dared him to go outside and wouldn't go.

I told Rick not to worry about it, that I probably wouldn't have gone either (but I wouldn't have let him put me down, so I don't know what would've happened if it was me). I think I calmed Rick down.

And I told Raymond later, "You lucky bastard, I saved your life because he would have killed you." Raymond didn't understand. He didn't know what the problem was. But I saved his life and he knows it.

I managed to keep myself busy that season but I was still concerned about my future in the NFL and with the Packers. Remember, Rozelle had said the ban was indefinite, so I had no idea what he would decide. I had been on my best behavior all year. I had done no gambling and I stayed away from the situations that I thought might get me in trouble. Now, I still went to Vegas a few times during that year but I'd always call Lombardi and tell him I was going and what I was doing and he'd say okay.

I never had trouble staying away from gambling. It wasn't like I was addicted to it; when I did it I enjoyed it. That was all. So on the times

Me and Angela with her favorite, Greg Norman, along with Billy Kilmer and his wife.

I went to Las Vegas, I would play golf almost every day and make appearances. It wasn't like I was being lured into gambling again.

I remember Pete Rozelle invited me to New York in March the next year for a talk and I had hoped that would be the day he announced his decision about the 1964 season. But he just asked me a few questions about the people I'd been associated with. I wasn't sure what the point of that was, but I left frustrated and little angry.

Finally, and I remember the date, it was April 17, 1964, when I got the call that the suspension was lifted for both myself and Karras. I was in Miami at the time and I felt great. I had missed football a lot and, more than that, I'd missed being with my teammates. It had been a long year and I believed I had handled myself the best way I could. I had to promise I would never gamble again and I didn't.

I know a lot of people think I held a grudge against Pete Rozelle for what he did. But I never did. Sure, the NFL was probably being hypocritical for suspending me and Karras when a lot of players,

and I mean a lot of them, were gambling. But I was guilty and they caught me and he did what he had to do. I wrote Pete later and told him I thought he was the best commissioner in professional sports and I still believe that. He did what he had to do and I understood that then and understand it now.

I remember I called Lombardi as soon as I heard the suspension was lifted and the first thing he said was that he wanted me in Green Bay six weeks before training camp. That was fine with me. I was pumped up. Vince made sure I was in the best shape of my life so I came back early and ran the steps of Lambeau Field every day. There were 64 steps and if you think I didn't count them, you're crazy. I was ready for a great season.

I worked really hard that off-season and heading into the season and, if anything, I probably overdid it. My best playing weight had always been around 215 pounds but I came into camp at around 200 pounds and that was a little too light for what Lombardi had in mind for me.

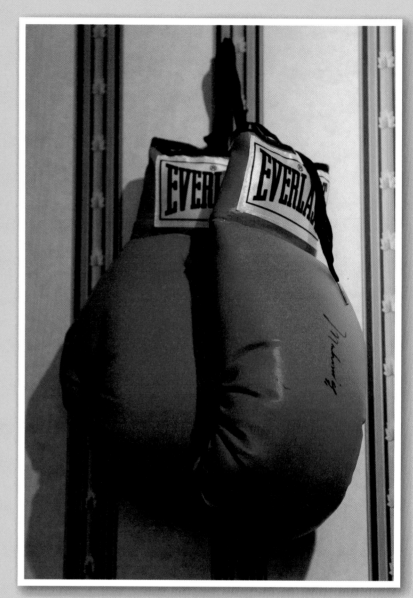

Muhammad
Ali's gloves.

Jimmy Taylor had clearly established himself as one of the top backs in the NFL and my job was to do a little bit more blocking than I'd done in the past. My knees were giving me trouble and I couldn't run the way I once did, but I was okay with blocking. I was always a pretty good blocker. But it began to take a toll on my shoulders, especially as camp wore on.

It ended up being an odd season. A lot of the pieces were still in place for us to be the best team in the NFL. In fact, Lombardi still wasn't convinced that we weren't the best team in the league from the previous season. As much as he hated losing, he could deal with it if he knew someone outplayed his group and had better talent. He was never convinced that Bears team was that good and that sort of played out in 1964 when the Bears fell back to 5–9 for the season. But that was history now.

We beat the Bears in the season opener after losing to them twice the year before and, in my first game in over a year, I did all right. I ran for 77 yards and kicked three field goals. Even George Halas, the Bears coach, said it didn't look like I'd been away a year. That was nice to hear.

But I was hurting. I'd come into the season in the best shape of my life but injuries, especially to my knees, were starting to pile up. I couldn't kick the damn ball anymore either. I missed a bunch of field goals that I never used to miss and I even missed two extra points. That might not have seemed like such a big deal, but they came in two games we lost by a point. That pissed me off. I knew I couldn't kick like I once did so the Packers picked up a veteran guy Don Chandler, who had spent his first nine seasons with the Giants, to handle the kicks starting in 1965. That was a good move.

We finished 8–5–1 that season, the first time we'd lost that many games since Lombardi's first season in 1959. But it was strange, we lost those five games by a total of 25 points, so a few players here and there might have made the difference. My season was okay, but nothing special, and I could feel the years catching up to me.

I also had a few more run-ins with Lombardi than I'd had in the past. I remember he was upset to see me in the training room so often. I don't

Miami, Florida: Billy Kilmer, jockey Eddie Arcaro, coach Don Shula, and me.

Me, Joe DiMaggio, and Eddie Arcaro in Florida.

know if he thought I was getting soft or the year off had changed me. But I was beat up and I felt it. Then there was the time he caught me in Chicago drinking at a restaurant the day before a game with the Bears. He actually showed up at the same restaurant I had recommended to him but I never figured he'd go there. So when he saw me with a drink he went crazy. He was so pissed. He threatened to suspend and fine me. I did apologize and back at the hotel he had calmed down and didn't suspend me, though the fine stayed in place.

As I said, we finished 8–5–1 that season and finished tied for second in the Western Division with the Minnesota Vikings, and behind the champion Baltimore Colts. I remember we ended up playing in something called the Runner-Up Bowl, a stupid damned idea that put us against the St. Louis Cardinals in a game that meant absolutely nothing. I remember Lombardi called it the "Shit Bowl" and I didn't disagree. It was. We lost, but who cared? That idea was scrapped the next year, I think.

I came back in 1965, again, in really good shape. I kind of thought I was looking at the end of my career anyway and I was determined to go out as strong as I could. Again, there were rumors that Lombardi was done with me and was thinking of trading me. But I remember he called me one night and denied it. He said injuries hurt me in '64 but he was convinced '65 would be better.

That was also the year that the Packers renamed City Stadium for the Packers first coach, Curly Lambeau. I remember that. We were playing the Colts and they had a hell of a team, just a great team, as we'd find out all that season.

Curly Lambeau had died in June of '65 and while he left the team on really bad terms 10 years or so earlier, he was still so closely identified with the Packers. I mean, there would be no Green Bay Packers without Curly Lambeau, who was born and raised in Green Bay and who had the idea of starting a professional football team in the little town. And try to think of the NFL without the Green Bay Packers. It's impossible.

Anyway, as a tribute to their first coach, the Packers decided to rename our stadium Lambeau Field. Actually, try to think of the NFL without Lambeau Field too. That's also impossible.

But I remember Lombardi was furious about it. First, the dedication took the focus away from his team and the really big game we were playing that day. Second, he didn't have much use for Lambeau. On the surface, he said all the right things but he thought Lambeau was an SOB and a womanizer who hadn't earned the right to have stadium named after him.

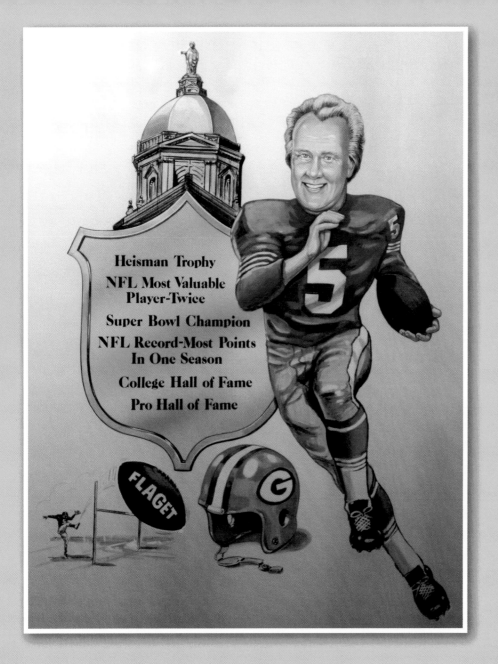

Heisman Trophy
NFL Most Valuable
Player-Twice
Super Bowl Champion
NFL Record-Most Points
In One Season
College Hall of Fame
Pro Hall of Fame

FLAGET

Deep down, I think Lombardi eventually wanted the stadium named after him. But there's Lombardi Avenue that runs right outside the stadium and, of course, the Super Bowl trophy is named for him, so I think he got the better deal.

We won that game and started the season 6–0 and then we lost three of our next five games and I was getting pissed because I wasn't playing much because my knees were acting up again. Then we went to Baltimore for another key game, as we were both battling for the Western Division.

Roastin' The Golden Boy

7TH ANNUAL LIFE TREATMENT CENTERS ROAST

Eric Walton

I stayed out the night before and wasn't sure what kind of shape I'd be in for the game, but I found out soon enough. That was the game where I scored five touchdowns. It was a hell of a day for me and a hell of a game too. It was a great game played by two good teams really going at it. Those are fun games to be a part of. I ran in for three touchdowns of two, nine, and three yards and I caught two long passes from Bart—50 and 65 yards—for my other two. Those were the only two passes I caught all day and both went for touchdowns, including the last one which sealed the 42–27 win. It was just a great game. I scored eight touchdowns all season and five came in that one game, pretty strange.

I remember years later, I was given a photo of me scoring one of my five touchdowns and I showed it to my pal, Chicago Bears running back Gale Sayers. That SOB went and signed it, "But I scored 6 TDs against the 49ers the same day." I told him, "Yeah, but that game didn't mean anything. Ours did." That was pretty funny.

There was a great back, Gale Sayers. Oh my God, could he play. The first time I saw Gale play I knew he'd be special. I said, "Keep your nose clean, stay out of trouble, and you'll be the best back ever." It's a damn shame what happened to him with his knee injury in 1968 because there's no telling what he could have done. He was that good. I mean, he was still a great back but he was never quite the same after the injury. He's in the Hall of Fame, as he should be, but he only played in 68 games. Just an incredible talent.

That was a hell of season because we finished 10–3–1 and we tied with the Colts for the division title, so we faced each other for the third time that season, a playoff game for the right to meet the Cleveland Browns for the NFL title.

It was another great game, but for a different reason. The Colts were playing without their star quarterback Johnny Unitas, who had been

Fuzzy Thurston, me, and Max McGee singing "He's Got the Whole World In His Hands" to Lombardi at the coach's going-away party.

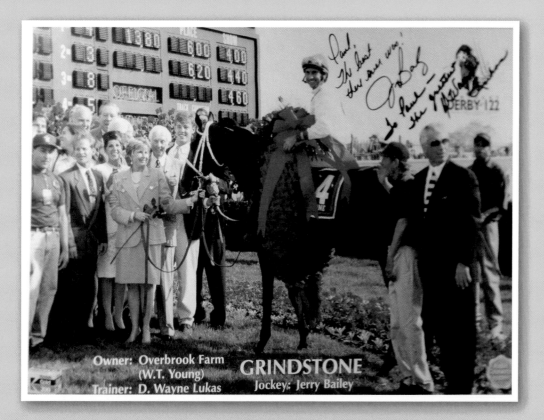

Owner: Overbrook Farm
(W.T. Young)
Trainer: D. Wayne Lukas
GRINDSTONE
Jockey: Jerry Bailey

hurt a few weeks earlier, and backup Gary Cuozzo, who was hurt the week following that. So in this game, where a trip to the NFL championship was on the line, the Colts had to use running back Tom Matte at quarterback. He did a hell of a job for someone who didn't know what he was doing.

We had our own problems because, early in the game, Bart injured his ribs trying to make a tackle and he was lost for the rest of the game too. We went with old reliable backup Zeke Bratkowski, who was outstanding.

It was a tight, conservative game that came down to the final minute, when Don Chandler kicked a field goal to tie the game. From where I stood, I thought he made it easily but he shook his head in disgust as though he'd missed out. Turns out it was damn close—barely sliding inside the left upright. That sent it to overtime and Chandler kicked another field goal and we had the win.

You almost had to feel bad for the Colts. They had given it everything they had and came up short. They finished 10–4–1 that season and three of their losses came against us.

After those wars against the Colts, the championship game against the Cleveland Browns almost seemed anti-climactic. But the Browns also had the guy who I still think is the greatest running back of all time, Jim Brown. He and I first met in the college all-star game nearly a decade ago and I knew then how good he'd be. And he didn't disappoint as he established himself as the most punishing back in the league. He's still the best in my book.

But on this day, he wasn't at his best because Lambeau Field was a mess after a pretty good snowfall earlier in the day. He only had 50 yards in the game while Jimmy Taylor, who had always taken it as a personal insult that his name wasn't mentioned in the same sentence with Brown, ran for 96 yards. He was named the game's MVP, though I played pretty damned well too, running for 105 yards and scoring what proved to be the winning touchdown in a 23–12 win. It was our third championship in five years.

That proved to be Jimmy Brown's last game. He decided he'd had enough and was going to step away from the game while he had his wits and his body still in one piece. Besides, Hollywood was calling and he was ready to make movies. He had already become a star with *The Dirty Dozen,* and football just didn't do it for him anymore. I could understand and a part of me wondered if I should do the same thing.

Changes were coming to pro football too. The AFL had bugged Pete Rozelle and the NFL for years now, gaining in popularity and signing some big-time college talent that at one time had belonged to the NFL.

So in June of 1966, the two leagues merged and would add a new team in 1967, the New Orleans Saints.

There would also be a championship game featuring the best of the NFL against the best of the AFL. In time, it would come to be known as the Super Bowl, a silly title, we all thought, that had been the brainstorm of Kansas City Chiefs owner Lamar Hunt and was based on the kids' toy, the Super Ball.

Other things were changing too. The nucleus of our team was starting to fall away a little bit. My great friend, and still one of the best tight ends to ever play the game, Ron Kramer, was traded to the Detroit Lions.

Autographs for my mom while I was suspended.
Notice what Max McGee wrote.

DAVEY O'BRIEN

LEGENDS AWARD

Presented by

THE
DAVEY
O'BRIEN
FOUNDATION

PAUL HORNUNG
February 19, 2007

One of the greatest offensive linemen of all time, Forrest Gregg, retired, and my friend Fuzzy Thurston, another great lineman, would miss the entire season with injuries.

I knew I wasn't the player I had once been either. Injuries, especially a troublesome neck problem, dogged me all year. Still, I had a pretty good year, though as the season went on it was becoming tougher to perform at a high level.

But we all know what happened. We won that first NFL-AFL title game easily over the Chiefs, and though I didn't play due to injuries, I still knew I had played a major part in the historic game.

But I could hear the voices again. With the Saints joining the NFL in 1967, every other team in the league had to submit a list of 11 names of players that the Saints could pick from. Lombardi, who wasn't sure if I'd ever play again, put my name on the list, which, frankly, was okay with me.

And it turned out, I was the first player taken in the expansion draft by coach Tom Fears and Vince was really pissed at the Saints for taking me, but I think Tom Fears knew I could help him. They took Jim Taylor too, so they had a ready-made backfield. But I knew I couldn't play right away because of my neck. I was hoping I'd be able to play because I thought I could help them.

Of course, I also had already worked out a pretty good deal with the team for more money that I was getting in Green Bay and which would include a TV and radio deal. So I was looking forward to going to New Orleans.

I went to training camp, which was held in San Diego, and I was anxious to show what I could still do. I knew I wasn't the player I had been, but I figured I still had something left. But recurring problems with my arms, which kept going numb, were bothering me. Even though I'd been cleared by a doctor to play (in fact he said I was okay to play in the first Super Bowl), I didn't feel right; something just wasn't right.

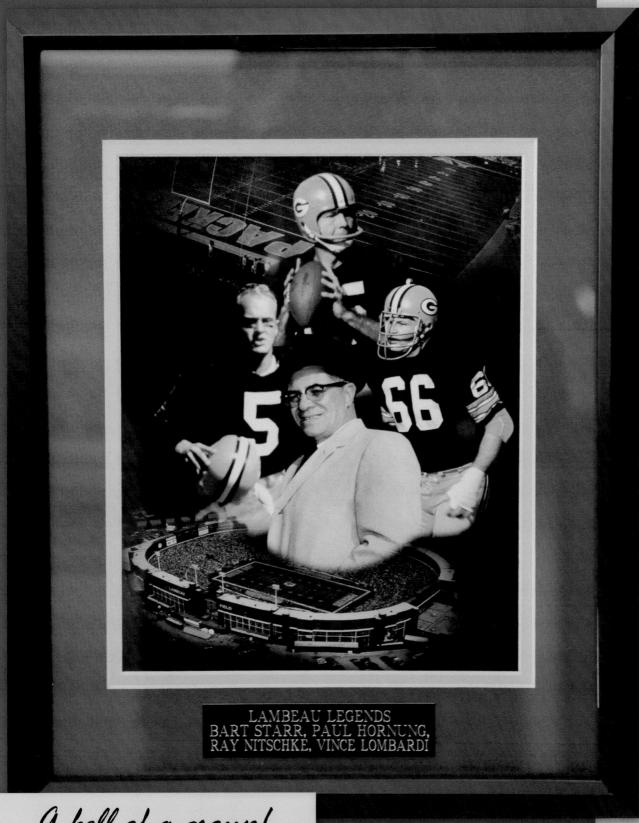

LAMBEAU LEGENDS
BART STARR, PAUL HORNUNG,
RAY NITSCHKE, VINCE LOMBARDI

A hell of a group!

To
Paul
Your #1

An autograph from
my friend Mike Ditka.

A drawing of Ditka and me on my TV show in Louisville.

by: JonSiau

I went for a second opinion in San Diego, before camp started, and I'll never forget this. The doctor looked at the X-rays and said, "You mean a doctor in Houston actually cleared you to play? Are you crazy?" And then he said I had a subluxation of the fifth and sixth cervical vertebrae. That meant, as far as I knew, that the vertebrae in my back weren't aligned properly anymore and another hit could render me a paraplegic.

That scared the hell out of me and I knew then that nothing was worth being paralyzed. The doctor's advice was simple. He said retire right away. He said don't even think about it. So naturally, I listened. I quit the next day. I hadn't even gone through pre-practice yet with the Saints, who were getting ready for training camp.

I wasn't going to chance it, so I retired the next day.

It was a Monday night, on the Joey Bishop show. He said, "I hear Paul Hornung made a decision today that he wasn't going to play anymore. Is that right?" And I said, "That's right." And that was it.

I wondered if there was one game where it might have happened but I was told it was the cumulative effect of taking so many hits. It's the same thing they're talking about in the NFL today with concussions. I know I had a couple of injuries to the head and it's starting to impact me a little. In fact, I'm going to file my own lawsuit against the NFL saying they didn't properly inform us about the effects of concussions. I'm going to be filing that soon and I've got the best attorney in the world in Ed Glasscock.

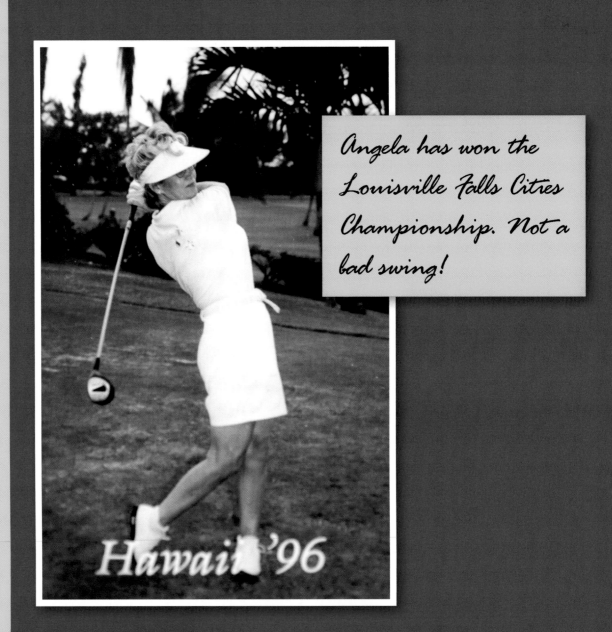

Hawaii '96

Angela has won the Louisville Falls Cities Championship. Not a bad swing!

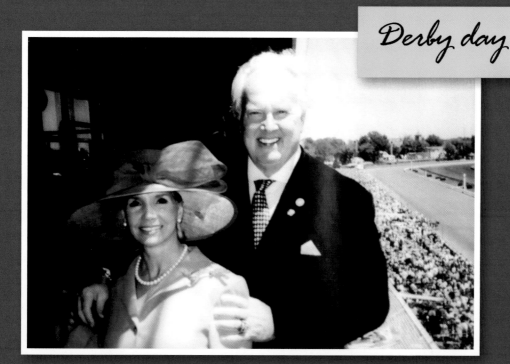

I played nine seasons and while there are a lot of people who think I never got everything out of my career that I could have, I've never looked at it that way.

I never worried about that. I did what I did and that was it. I was very fortunate to play on some pretty good teams. That's the way I looked at it. Actually, I played on some great teams.

I feel very fortunate I was with the Packers. I think we were a special group. There are not too many teams that have the whole backfield in the Hall of Fame like we did with Jimmy Taylor, Bart Starr, and me. Then you have Forrest Gregg, Ray Nitshcke, Herb Adderley, Henry Jordan, and Willie Davis. Not too many teams have had that many people in the Hall of Fame. I think it was as special team and a special coach. It's a good match and players are lucky when they get a good match.

Life After the NFL

I wasn't one of those players who wasn't ready for my career to end. I guess I was in the right place at the right time. It was a good match between me and the Packers and I knew that was probably never going to be seen again. And I guess I was one of the lucky ones because my body gave me the warning I needed and I was able to get out before it was too late. I'll always be grateful for that.

Besides when I retired, I did so in a city I really liked. I enjoyed New Orleans and I stayed there and did radio and TV for two or three years and worked as a public relations guy for the Saints. It was a good situation. The Saints owner was a good guy and he loved football and had a lot of money so it worked out really well for me. Jimmy Taylor also played there. That was his home and he was happy about that. But he got the hell beat out of him that season. So I enjoyed New Orleans. It wasn't a tough transition for me to leave football because I was ready. I loved the city and the city was good to me.

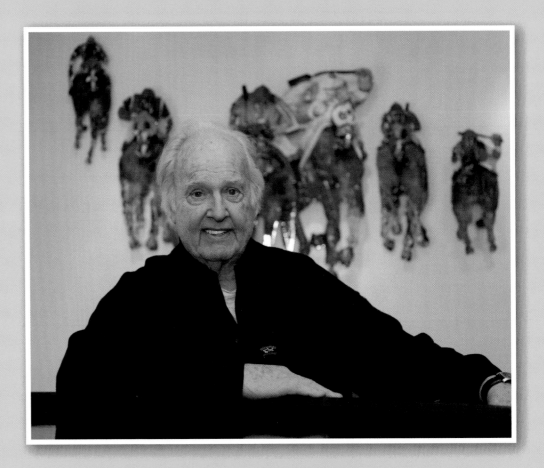

But as much as I loved it there, the Packers were still a part of me and I knew they always would be. The Packers were going through a transition because a lot of the players I'd played with were now either retiring or coming to the end of their careers. And after I retired, I'd still keep tabs on what was happening, mostly by phone with Max McGee.

I was down in Miami when the Packers won that second Super Bowl over the Raiders and you could tell something was changing. I think Jerry Kramer, that great guard who I still can't believe isn't in the Hall of Fame, told me that he knew before the game that this might be Lombardi's last game. He even told the team in the locker room before the game to win this one for the "old man," as though he knew it might be it. And, of course, it was.

I knew Lombardi wasn't happy just being the general manager and he knew pretty quickly that he'd probably made a mistake giving up the coaching part of the job. But it was one of those things where he knew it was probably time to step away before he was pushed and he'd made a promise to Phil that the job was his once he left.

The next year, and I can't say I was surprised, Vince announced he was leaving the Packers to take over the Washington Redskins, a franchise almost as hopeless as the Packers were when he took over in 1959.

I remember Sonny Jurgensen, the Redskins' great quarterback and someone who loved the nightlife as much as I did, called me right after it was announced Lombardi was taking over. He asked me what it was going to be like with him as the head coach. Jurgensen was another of those great players who had terrific numbers but had never been on a team that won. That was the way it was when he was in Philly and it had been the same thing in Washington. He just wanted to win so badly because he knew he didn't have too many years left in the game. I know he desperately hoped that Lombardi was the guy.

I remember I told him he'd love Lombardi. I told him he'd be tough but fair and that he would make him a better football player. That's all Sonny needed to hear.

And, of course, it happened. The Redskins, who hadn't had a winning season since 1955, went 7–5–2 with Lombardi as coach and it seemed Washington would see the kind of turnaround that we'd enjoyed in Green Bay.

My buddy Louie.

Sherrill Sipes and his daughter Stacy with me and Angela at the Derby.

Of course, Lombardi got sick soon after that and it just went downhill really fast. We'd go visit him in the hospital and he looked terrible, but he always said he'd be out of there and ready for the next season. He always said that.

I remember I was in Baltimore opening a new restaurant I owned when his wife called me and said he was really sick and on his last legs. She said that he was not going to make it and you better get here. So I got over there as fast I as could and he looked even worse. But he was glad to see me and he was coherent. He looked out the hospital window and he could see the Redskins' practice field. He said "I'm going to be out there next year." He believed that to the last day. I went back to Baltimore and the next day the phone rang and as soon as I picked it up I knew he hadn't made it.

I knew it was coming, we all did. He was really the only one who thought he was going to make it, but that's what made him so special. He was always looking to next year.

Me and my great friend Barney Shapiro at Alcatraz.

I remember I was riding in the car to the funeral with former Army coach Red Blaik and we were telling stories about Lombardi. Red Blaik did as much for his career as anyone. He told a story in the car that when he was coaching at Army, he'd have Lombardi, who was an assistant coach at the time, take game film of the Army game that day and drive it to New York City and show it to General Douglas MacArthur, who was retired and living at the Waldorf Hotel. He told Vince it was the most important thing he'd ever do. Take that film over, show the Army game to MacArthur, and talk to the general about the strategy of the game. I can only imagine those conversations between Lombardi and MacArthur. It must have been a hell of a time. We had a lot of great stories.

It was still hard to believe he was gone and his death really impacted me. That funeral was hard. Oh my God. It was held at St. Patrick's Cathedral in New York and it was packed.

All the guys who played for him knew how special he was but it's amazing how all these years later his message remains so strong. The most amazing thing is the legacy has lasted so long. As it becomes more and more important to become a leader today, Lombardi stands that much more important. It's about success and he'd still be a great coach today. That never changes.

The name Lombardi has endured in the concept of winning and work habits. They predicated a certain style of living after the coach. He would have been a great leader today.

He could have been a very, very popular coach today and I think the nation held him in high esteem. So we were lucky to have the opportunity to play for him. Our lives are still dependent on him.

My playing career was over and I was looking for the next challenge. I spent three or four years working in radio and TV and doing PR in New Orleans and I fell in love about 20 times. After that I went to Chicago and worked for CBS. I did a TV show there and I was doing color commentary for Notre Dame on the weekends with Lindsey Nelson. God, what a great guy. On Sundays, we'd travel after the Notre Dame game and Lindsey and I would do an NFL game. Lindsey was one of the best play-by-play guys around. People still remember his opening, "Hello everybody, I'm Lindsey Nelson." He was a great man. He was well respected. I loved Lindsey.

People have asked me if I ever thought about coaching and I never did. I never aspired to it. In those days you couldn't be a coach after playing—you had to put in your time as a coach and I really didn't want to do that. Besides, I was more interested in radio and TV.

I remember in 1970 after I'd been doing TV work with CBS and Notre Dame, I think it was 1974, when Don Meredith left *Monday Night Football.* Now back then, *Monday Night Football* was the biggest thing on television. My buddy Frank Gifford handled the play-by-play and Howard Cosell and Meredith played off each other like some comedy act. It was great television.

Angela and me at the unveiling of my statue at Louisville Slugger Field.

So when Meredith left the show, it was important to find the right person to fill his spot—if that was possible. I had known Howard Cosell for several years and we got along just fine and he recommended several people to replace Meredith. I was one of them and I think Dick Butkus was another. There were a couple of others too. In the end, the job went to Fred Williamson, the former defensive back of the Kansas City Chiefs, who had done some acting, and now was back in the booth. I thought it was a strange choice.

I remember the next spring I ran into Roone Arledge, the head of ABC and the man whose idea it was to start *Monday Night Football,* at the Kentucky Derby. I asked him why I didn't get the job and he was very honest with me. He said I was too much like Frank Gifford. I didn't understand what that meant. Did we look alike? Did we act alike? I wasn't sure what that meant but it didn't make any sense to argue. The decision was made.

I guess it's possible I wouldn't have worked out on *Monday Night Football* but I know for damn sure Fred Williamson didn't work out. He was fired before the regular season started. He was replaced by, of all people, Alex Karras, who did a really good job.

My Hall of Fame bust.

Hall of Fame weekend in Canton, Ohio. (From left to right: Lil, Jinx, my mom, me, Angela, and Angela's mom and dad.)

Notre Dame radio broadcast crew.

These are all firefighters from New York. I brought them to South Bend for a Notre Dame game after 9/11. They loved the trip and so did I!

GROUND - MY
ZERO - NY
2010
NO. NAVY

Everything professionally was going okay for me. I was staying busy in TV, though I do wish I'd given acting a more serious shot. I did a bit part in a movie called *The Devil's Brigade* and I did a small TV part where I played a cop. I think I might have had a pretty good career as an actor but I don't think I ever took it seriously enough. I regret that a little.

By this time, my marriage to Pat Roeder, who I'd married just a couple days after the first Super Bowl was long over. Really, we stayed together for only about a year, but we were officially married for about 10 years. I just never got around to getting a divorce. We weren't that compatible and I remember she really didn't like Louisville very much either.

Around 1980, I met a little Italian girl from Philadelphia named Angela Cervelli. Angie and my French bulldog, Louie, those are my two loves. Angela worked for the Philadelphia Eagles, she was coach Mike McCormack's secretary. I ran into her in Philadelphia at a cocktail party and for our first date I invited her to Baltimore for the Preakness. She came here to Louisville and we've been married for 35 years. Louie is a 12-year-old French bulldog. He's my second love and maybe Angela is first. She was the perfect woman for me.

She's also a damn good golfer. She won the city championship in Louisville three years ago. I don't play anymore because of my hips and knees. I've kind of given it up. I wish I could still play because I love the game so much.

Paul Ryan—a good Packers fan.

I've been awfully fortunate. I've done just about everything I set out to do and I've been lucky in that way. I was elected to the College Football Hall of Fame but even that didn't come easily. I thought I had a pretty good college career at Notre Dame. You know, I did win the Heisman Trophy. But the folks who ran the College Hall seemed to have it in for me. I guess it was because of my gambling suspension in the NFL, though what that had to do with my college career I didn't know.

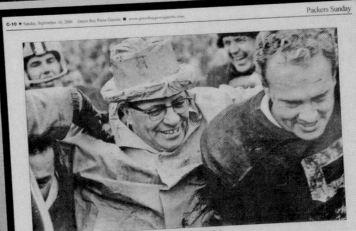

GREEN BAY PRESS-GAZETTE

Packers Sunday

C-10 ★ Sunday, September 10, 2006 · Green Bay Press-Gazette · www.greenbaypressgazette.com

Former Packers coach Vince Lombardi shares a smile with halfback Paul Hornung. *Photo courtesy of Triumph Books*

Hornung pays his respects

While writing about his relationship with Vince Lombardi, one of the Packers' greatest stars discovers he's still driven by the legendary coach's philosophy — even after more than 35 years

BY CHRIS HAVEL

Lombardi speaks to Hornung. Photo courtesy of Triumph Books

"Vince changed my life, and he came along at just the right time. My first two years with the Packers were so unhappy and unsatisfying that I was ready to quit and do something else."

— Paul Hornung, from his book "Lombardi and Me"

PAUL HORNUNG
Featured In: **The Green Bay Press-Gazette**
September 10, 2006

158

I think it was 1982 when I filed suit against the NCAA for $3 million for what was called "intentional interference with prospective relations." In other words, the NCAA felt I didn't fit their image of what college football was supposed to be and that view was keeping me from gaining employment as a TV analyst or anything else in college football. It wasn't fair.

Maybe it was irony, I don't know, but three years later as I waiting for my suit to go to trial, I was finally elected to the College Football Hall of Fame. Soon after that, a jury said I had indeed been wronged by the NCAA and awarded me a nice judgment. It wasn't an ego thing with me. I really felt that the NCAA was being hypocritical and I was just looking for what was right.

As for the Pro Football Hall of Fame? Well, I had pretty much given up on getting in. That was the only thing I hadn't accomplished. There were so many stories over the years about why I wasn't in the Hall of Fame and all of them were positive.

Those stories all said I should be in. But I had retired in 1967 and there's a five-year waiting period before a player is eligible. This was now 1986 and I figured everyone had forgotten about me.

For a while, the vote had always been pretty close but I never got enough votes. I had heard one writer, John Steadman from the *Baltimore News-American,* had always been the one that lobbied to keep me out. I didn't even know the guy, but he made it a point to not vote for me. He was also able to persuade some of the pro football writers to do the same. Obviously, he still had problems with my gambling suspension in 1963. Eventually, the gambling became a small point, I think, but every year I didn't get in, I was disappointed.

Bu something finally happened in 1986. I don't know if Steadman gave up his quest to keep me out or what, but, and I'll never forget the date, January 27, 1986, I learned I had been elected to the Pro Football of Fame. God, did that feel good.

I know it meant a lot to my mom too, who had always backed me in everything I'd done. Without her, I'm not sure I would have accomplished anything. She loved football. She came up for every Green Bay game. She worked for government and she worked her tail off. She died in 1992 at the age of 87 and I miss her every day.

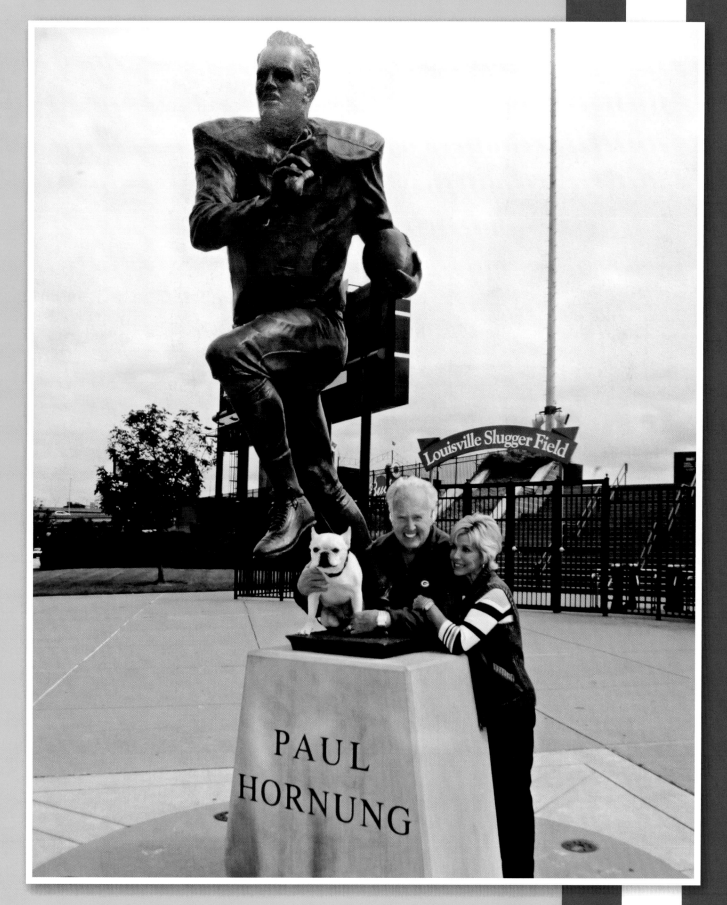

PAUL
HORNUNG

SECURITY BREACH
Paul Hornung &
Trainer Robert O'Connor, II - Owners
Robby Albarado - Up
Some Kinda Trouble - 2nd Pacificator - 3rd
7 Furlongs in 1:26.29 Purse $18,480
November 24, 2010

CHURCHILL DOWNS

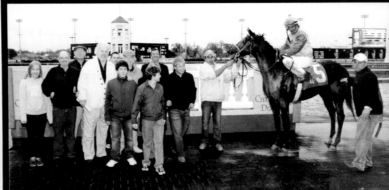

My favorite place to be—the Winners Circle.

Belmont Park, New York
Golden Boy Racing owner
Philip M. Serpe trainer
Ambassador 2nd

Purse $44,000
ANGELOUIE

May 5, 2007
Joe Bravo up
1 mile time 1:35:2
Rocket Legs 3rd

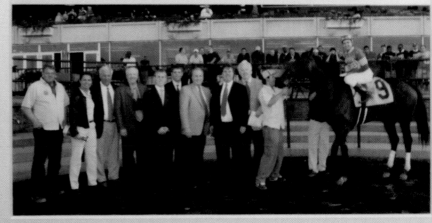

So the Hall of Fame induction was that summer in Canton, Ohio, and I still go there every year. I love going there. It was really hot that day, I remember that. I mean really hot and I was being inducted the same day with four other terrific players—safety Kenny Houston, linebacker Willie Lanier, running back Doak Walker, and a great quarterback in Fran Tarkenton.

It was an honor being with those four guys and it was an even bigger honor when I saw how many of my former teammates were there. Bart was there and so was Herb Adderley, Ray Nitschke, and Fuzzy Thurston, who was one of my best friends and who came even though he'd just had throat cancer surgery. He wasn't going to miss it. Fuzzy is so special to me. I'm the godfather to his kids. Ron Kramer was there and so was Forrest Gregg. What an honor that was.

Angela and Louie.

And, of course, I was introduced by the only person who could have done it—Max McGee. I remember he was so nervous before the ceremony and he made me nervous. His speech was typical Max. I'm not really an emotional guy but it got to me that day.

That was really the last thing in football that mattered to me. I did everything I wanted to do and I couldn't ask for more.

I still keep busy and I still love doing what I do. There are a bunch of us who are really professional Packers. That's what we do. We're making appearances to this day as football jocks. It amazes me, especially in Wisconsin. For the past 10 years I've been going to Summerfest in Milwaukee and signing autographs and the popularity is amazing. They still go back to those Lombardi years. We're still in high reverence from those days.

My favorite chair in my office, my dog Louie.

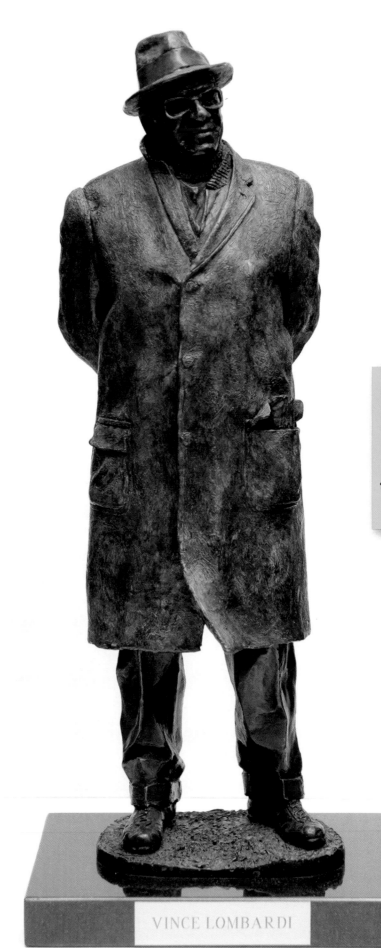

Statue of Coach in my office.

VINCE LOMBARDI

I still come into the office every day and I'm still involved in a few things. I still have company business, I have some McDonald's leases, and I own some property down in the west end of Louisville. It's down where I grew up. I'm still really involved with the Sister Visitor program, a charity that helps indigent girls and that's very important to me.

I still own three race horses too, and I will have a horse in the Kentucky Derby before I die.

I don't look back on my legacy. I did what I did and I was happy about that, but I don't think of it in those others terms. As I've said many times, I was very fortunate. I don't look back and say I was a special type player. I think I did okay.

I don't have many regrets, but I think we all get to a point after we quit that, after a while, you're done being a celebrity. You don't want it anymore. Sometimes you wish you weren't Paul Hornung. Still, it's been pretty nice being Paul Hornung.

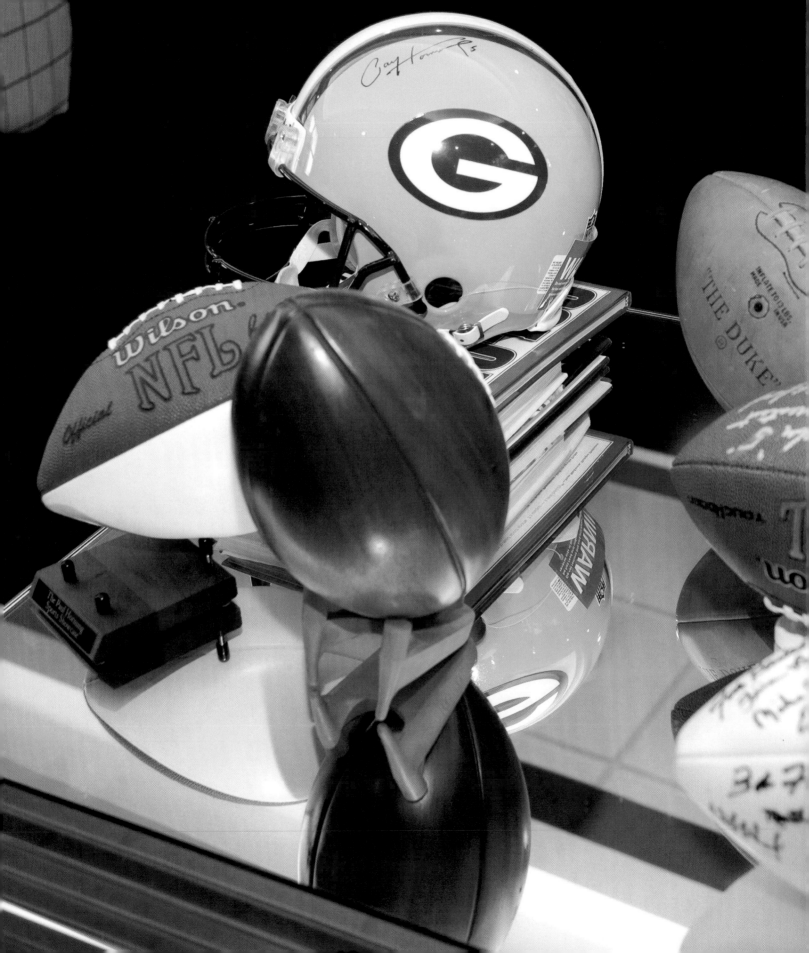

APPENDIX

College and NFL Stats and Awards

COLLEGE

PASSING

| Year | School | Conf | Pos | G | Passing | | | | | | | | | |
|------|--------|------|-----|---|-----|-----|------|-------|-----|------|----|-----|------|
| | | | | | Cmp | Att | Pct | Yds | Y/A | AY/A | TD | Int | Rate |
| 1954 | Notre Dame | Ind | QB | 10 | 5 | 19 | 26.3 | 36 | 1.9 | 1.9 | 0 | 0 | 42.2 |
| 1955 | Notre Dame | Ind | QB | 10 | 46 | 103 | 44.7 | 743 | 7.2 | 4.6 | 9 | 10 | 114.7 |
| 1956 | Notre Dame | Ind | QB | 10 | 59 | 111 | 53.2 | 917 | 8.3 | 3.5 | 3 | 13 | 108.0 |
| Career | Notre Dame | | | | 110 | 233 | 47.2 | 1,696 | 7.3 | 3.9 | 12 | 23 | 105.6 |

AWARDS AND HONORS

1955 Consensus All-America

1956 Heisman Memorial Trophy

RUSHING AND RECEIVING

Year	School	Conf	Pos	G	Rushing				Receiving				Scrimmage			
					Att	Yds	Avg	TD	Rec	Yds	Avg	TD	Plays	Yds	Avg	TD
1954	Notre Dame	Ind	QB	10	23	159	6.9						23	159	6.9	0
1955	Notre Dame	Ind	QB	10	92	472	5.1						92	472	5.1	0
1956	Notre Dame	Ind	QB	10	94	420	4.5	6	3	26	8.7	0	97	446	4.6	6
Career	Notre Dame				209	1,051	5.0	6	3	26	8.7	0	212	1,077	5.1	6

HEISMAN VOTING

1955 321 Points (5th)

1956 1066 Points (1st)

RUSHING AND RECEIVING

Year	Age	Tm	Pos	No.	G	Rushing						
						Att	Yds	TD	Lng	Y/A	Y/G	A/G
1957	22	GNB	FB	5	12	60	319	3	72	5.3	26.6	5.0
1958	23	GNB	FB/K	5	12	69	310	2	55	4.5	25.8	5.8
1959*	24	GNB	K/LH	5	12	152	681	7	63	4.5	56.8	12.7
1960*+	25	GNB	HB/K	5	12	160	671	13	37	4.2	55.9	13.3
1961+	26	GNB	HB/K	5	12	127	597	8	54	4.7	49.8	10.6
1962	27	GNB	HB	5	9	57	219	5	37	3.8	24.3	6.3
1964	29	GNB	HB/K	5	14	103	415	5	40	4.0	29.6	7.4
1965	30	GNB	HB	5	12	89	299	5	17	3.4	24.9	7.4
1966	**31**	**GNB**	**HB**	**5**	**9**	**76**	**200**	**2**	**9**	**2.6**	**22.2**	**8.4**
					104	893	3711	50	72	4.2	35.7	8.6

KICKING

Year	Age	Tm	Pos	No.	G	0-19		20-29		30-39	
						FGA	FGM	FGA	FGM	FGA	FGM
1957	22	GNB	FB	5	12						
1958	23	GNB	FB/K	5	12						
1959*	24	GNB	K/LH	5	12						
1960*+	25	GNB	HB/K	5	12	7	3	6	5	9	4
1961+	26	GNB	HB/K	5	12	9	8	4	3	4	2
1962	27	GNB	HB	5	9	5	4	2	1	1	
1964	29	GNB	HB/K	5	14	7	3	9	5	10	1
					104	28	18	21	14	24	7

Receiving										
Rec	Yds	Y/R	TD	Lng	R/G	Y/G	YScm	RRTD	Fmb	AV
6	34	5.7	0	16	0.5	2.8	353	3	2	
15	137	9.1	0	39	1.3	11.4	447	2	1	
15	113	7.5	0	19	1.3	9.4	794	7	7	
28	257	9.2	2	33	2.3	21.4	928	15	3	16
15	145	9.7	2	34	1.3	12.1	742	10	1	14
9	168	18.7	2	83	1.0	18.7	387	7	1	6
9	98	10.9	0	40	0.6	7.0	513	5	4	3
19	336	17.7	3	65	1.6	28.0	635	8	2	7
14	**192**	**13.7**	**3**	**44**	**1.6**	**21.3**	**392**	**5**	**1**	**4**
130	**1480**	**11.4**	**12**	**83**	**1.3**	**14.2**	**5191**	**62**	**22**	**50**

40-49		50+		Tot			PAT		
FGA	FGM	FGA	FGM	FGA	FGM	FG%	XPA	XPM	XP%
				4		0.0%			
				21	11	52.4%	23	22	95.7%
				17	7	41.2%	32	31	96.9%
5	3	1		28	15	53.6%	41	41	100.0%
1	1	4	1	22	15	68.2%	41	41	100.0%
2	1			10	6	60.0%	14	14	100.0%
11	2	1	1	38	12	31.6%	43	41	95.3%
19	**7**	**6**	**2**	**140**	**66**	**47.1%**	**194**	**190**	**97.9%**

PASSING

Year	Age	Tm	Pos	No.	G	Cmp	Att	Cmp%	Yds	TD	TD%
1957	22	GNB	FB	5	12	1	6	16.7	-1	0	0.0
1958	23	GNB	FB/K	5	12	0	1	0.0	0	0	0.0
1959*	24	GNB	K/LH	5	12	5	8	62.5	95	2	25.0
1960*+	25	GNB	HB/K	5	12	6	16	37.5	118	2	12.5
1961+	26	GNB	HB/K	5	12	3	5	60.0	42	1	20.0
1962	27	GNB	HB	5	9	4	6	66.7	80	0	0.0
1964	29	GNB	HB/K	5	14	3	10	30.0	25	0	0.0
1965	30	GNB	HB	5	12	1	2	50.0	19	0	0.0
1966	31	GNB	HB	5	9	1	1	100.0	5	0	0.0
Career					104	24	55	43.6	383	5	9.1

SCORING SUMMARY

Year	Age	Tm	Pos	No.	G	GS	RshTD	RecTD	AllTD	XPM	FGM	Pts
1957	22	GNB	FB	5	12		3		3			18
1958	23	GNB	FB/K	5	12		2		2	22	11	67
1959*	24	GNB	K/LH	5	12		7		7	31	7	94
1960*+	25	GNB	HB/K	5	12		13	2	15	41	15	176
1961+	26	GNB	HB/K	5	12		8	2	10	41	15	146
1962	27	GNB	HB	5	9		5	2	7	14	6	74
1964	29	GNB	HB/K	5	14		5		5	41	12	107
1965	30	GNB	HB	5	12		5	3	8			48
1966	31	GNB	HB	5	9		2	3	5			30
Career					104		50	12	62	190	66	760

Int	Int%	Lng	Y/A	AY/A	Y/C	Y/G	Rate
0	0.0	-1	-0.2	-0.2	-1.0	-0.1	39.6
0	0.0	0	0.0	0.0		0.0	39.6
0	0.0	30	11.9	16.9	19.0	7.9	143.2
0	0.0	40	7.4	9.9	19.7	9.8	103.6
0	0.0	20	8.4	12.4	14.0	3.5	126.7
2	33.3	41	13.3	-1.7	20.0	8.9	70.1
1	10.0	10	2.5	-2.0	8.3	1.8	0.0
1	50.0	19	9.5	-13.0	19.0	1.6	43.7
0	0.0	5	5.0	5.0	5.0	0.6	87.5
4	7.3	41	7.0	5.5	16.0	3.7	67.5

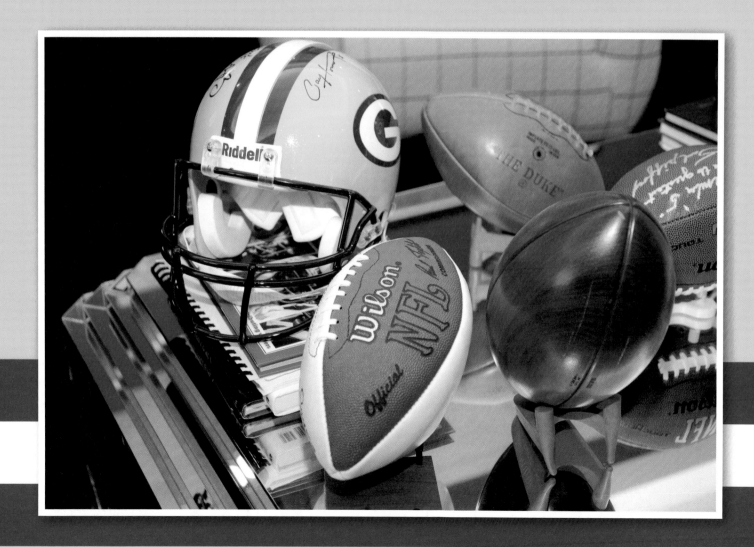

AWARDS

1961 NFL AP MVP

1961 NFL UPI MVP

1961 NFL Bert Bell Award (Player of the Year)

Pro Football Hall of Fame team All-1960s Team

PRO BOWLS

1959

1960

FIRST-TEAM ALL-PRO

1960

1961